ABANDONED
LOUISIANA

UNDER A BAYOU MOON

12

MIKE COOPER

AMERICA
THROUGH TIME®
ADDING COLOR TO AMERICAN HISTORY

America Through Time is an imprint of Fonthill Media LLC
www.through-time.com
office@through-time.com

Published by Arcadia Publishing by arrangement with Fonthill Media LLC
For all general information, please contact Arcadia Publishing:
Telephone: 843-853-2070
Fax: 843-853-0044
E-mail: sales@arcadiapublishing.com
For customer service and orders:
Toll-Free 1-888-313-2665

www.arcadiapublishing.com

First published 2020

ISBN 978-1-63499-267-1

Typeset in Trade Gothic
Printed and bound in England

CONTENTS

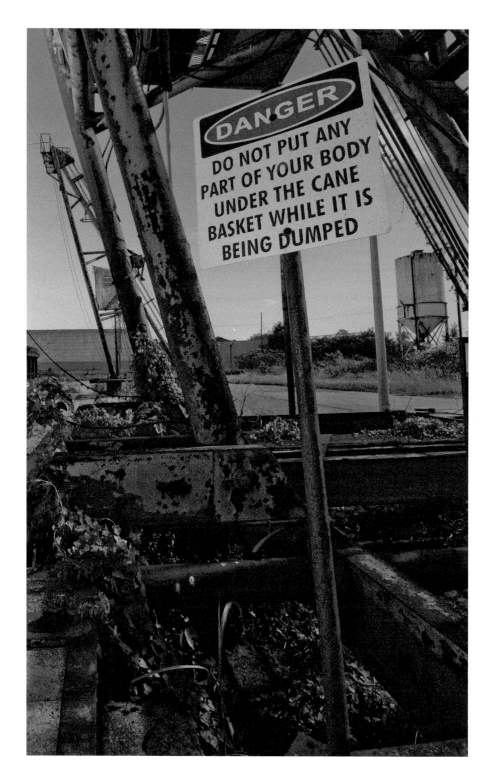

ACKNOWLEDGMENTS

Thanks to Troy Paiva for inspiring me to pursue shooting photos of things in the dark; Ken Lee and Tim Little for constantly giving me tips and ideas, as well as pushing me out of my comfort zone; Jeff Myers for supporting my odd shift from building cars to taking pictures in the dark and always believing I would one day have a book (this book); and my wife, Karen, and daughter, Courtney, who have been my biggest supporters and cheerleaders, as well as my best editors.

A special shout out and thanks to Jay Slater and the rest of the staff at Fonthill Media for giving me this opportunity.

CREATING THE IMAGES

In 2009, I was surfing the internet and found some photos taken by Troy Paiva of a few places that I had photographed in the daylight. His photos had the "it" factor that I wanted mine to have, but until that moment, I hadn't realized what "it" was that my photos were missing. I did some research and a test shoot on a combine, and I was immediately hooked. From that time on, the time I spent in the garage working on cars shrank more and more while my time spent either looking for places to shoot, or actually photographing them, increased at the same rate.

Photographing at night using long exposures and adding colored light to a subject that most people would consider an eyesore is a creative experience that gives new life and a vibrant feeling to an old, tired item. Capturing a photo of a place that is on the verge of collapse can be rewarding, and it gives you the satisfaction of documenting something that may soon be gone. The pictures on these pages were all taken on nights during or around a full moon. The exposures vary in length from thirty seconds to four minutes. Although it seems odd that a picture can be taken at night, the moon adds enough light during the extended exposure to make it appear quite light. The colors in these photos are all done using a ProtoMachines handheld light painting device. I only used Photoshop to make a few minor adjustments to exposure or to remove the occasional fence post or shadow.

INTRODUCTION

The Bayou State is so much more than just the French Quarter in New Orleans. The entire state is a diverse, beautiful landscape full of history and wildlife. The northern part of the state can be almost Western-like in some areas, but it still has that downhome Southern feel, while much of the southern portion of the state is full of Cajun and Creole lore. Many of the locations on these pages have long been forgotten and many are hidden on rarely-traveled backroads. These photos represent a historical range of more than 200 years, from an eighteenth-century church building to the columns of a long-burned plantation constructed in 1824 to a water park built as recently as 2012.

Louisiana is a state where the water is never far from one's mind. Throughout history, the region has been plagued by hurricanes and life-altering floods. The Mississippi River is an ever-present artery that defines much of the region, and even today, property lines along the River echo the plantation-era need to have waterfront property. Many of the sites in this book are abandoned because of flood and storm damage and some were moved to their present locations when the Mississippi River levees were built. But the people in Louisiana are strong and resilient, and although the state continues to grow and change, I hope my photos show a side of the state that many have forgotten.

In the course of making this book, I travelled more than 4,000 miles on paved, gravel, and dirt roads as I crisscrossed the state. I got lost more than a few times, had my car stuck up to the rear axle in mud, and was asked by a sheriff to leave because he didn't want any more people calling him to tell him someone was waving a flashlight around outside an old gas station. I took more than 850 pictures, using two different cameras (the first one had to be replaced after my tripod tipped over late one night down in Plaquemines Parish). When you figure an average of three minutes per photo, it adds up to a lot of time roaming around Louisiana in the dark!

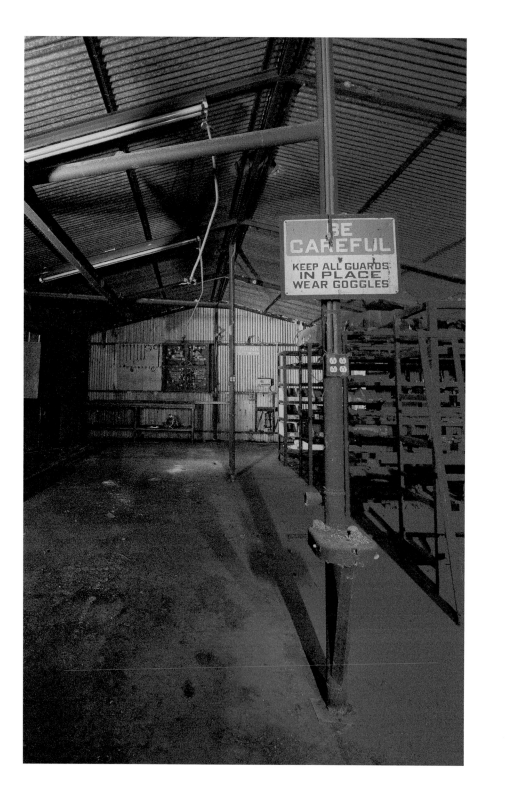

1

SAVING SOULS AND LIFE EVERLASTING

From the earliest days, faith has been a large part of Louisiana's culture. A local church could be anything from a humble, one-room frame building to a huge, elaborate structure. Some of these churches were the first pieces of property that newly-freed slaves could call their own. Others marked the passing of time from when the very first European settlers arrived in the region more than 300 years ago. Regardless of its size or origin, a church was so much more than just walls and windows. Instead, it was a place of community: a place where parishioners could profess their religious beliefs, celebrate their births and weddings, and mourn their loved ones.

I found old, abandoned churches of all sizes throughout Louisiana. Most were on quiet dirt roads and some were surrounded by overgrown cemeteries. While I was researching the backstories for these buildings, I was overwhelmed by the history of each. There were churches that served as schools, others that were constructed by ex-slaves on land carved out from former plantation land, and still others that had been physically moved to avoid the ever-present danger of the Mississippi River.

One cannot study churches without finding cemeteries. New Orleans, especially, is known for its Cities of the Dead, where generations of families occupy the same tomb. A walk through these cemeteries is like walking through time.

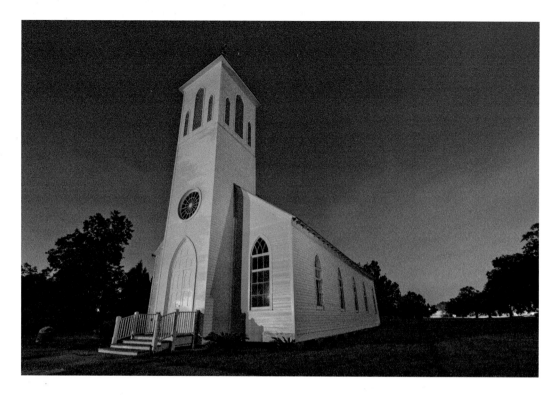

▲ This church was built in 1768 using cypress from nearby swamps. It is thought to be the oldest existing church building in the entire Louisiana Purchase territory. In the early twentieth century, the church was moved a little further away from the river to what is now its actual site.

▼ These columns are all that remain from a First Baptist Church built in the early 1840s. It burned in the late 1800s.

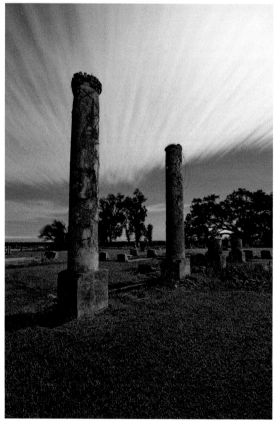

▶ The St. Stephens Episcopal Church was established in 1848 and this building was completed in 1858. It was built from local materials and bricks that were molded and burned on site starting in 1850. It is the oldest brick building still standing in Point Coupee Parish.

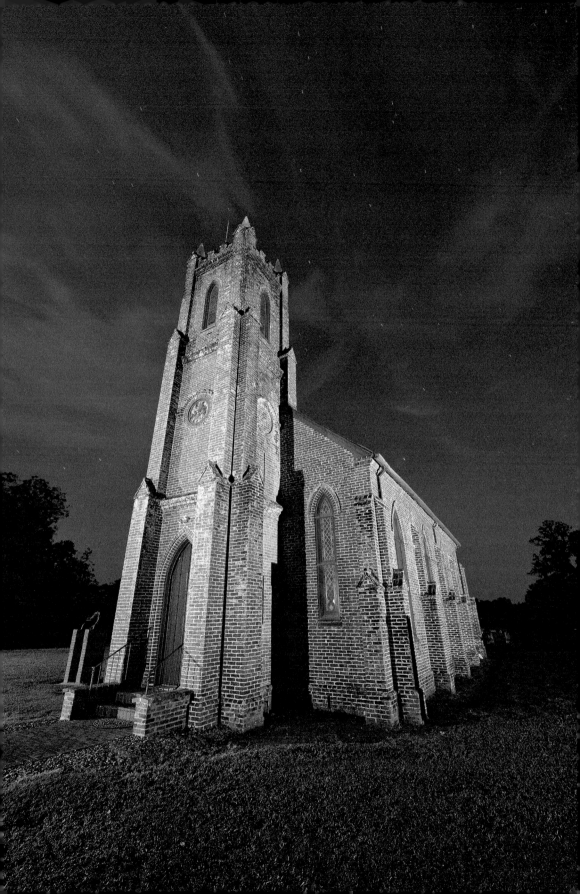

► This church and cemetery are the only remaining signs of the existence of a town incorporated in 1852. At one time, this town was the parish seat, but late one night in approximately 1892, someone broke into the courthouse, stole all records, and set the town on fire—leaving only this church. The parish seat was then moved to the nearest town six miles away.

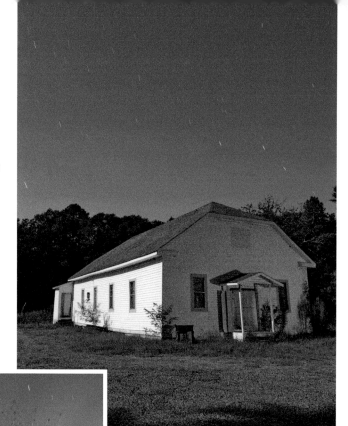

◄ St. Mary's Episcopal Church, built in 1857 in the Gothic Revival style, was consecrated by Bishop (and future Confederate general) Leonidas Polk.

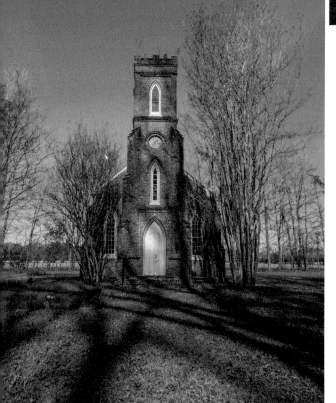

► This church was built in 1870 and these windows are painted glass rather than stained glass, as painted glass was more economically feasible for poor congregations. Many former slaves from nearby Welham Plantation attended services here.

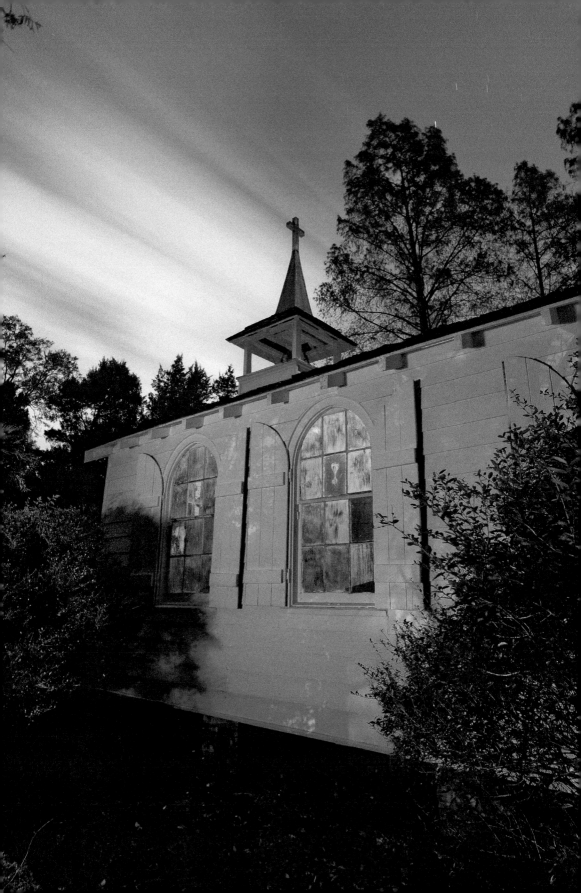

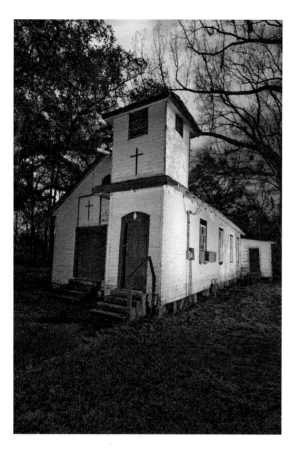

▲ Eagle Eye Baptist Church was one of the oldest historically Black church buildings in the parish; its actual build date is unknown. The property includes an overgrown cemetery dating back to the late eighteenth century, which contains the burial sites of some of the town's first families and historic figures.

▼ Rock Chapel was hand built in 1891 by Carmelite monks using local stone and mud plaster and is the last remnant of an old Carmelite monastery.

► The interior of Rock Chapel features frescoes that were originally hand-painted by two French monks in the 1890s and later restored in the 1960s.

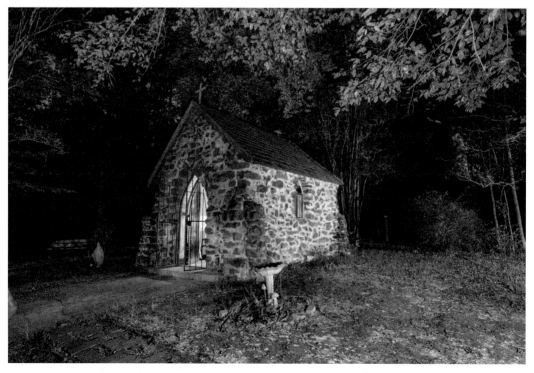

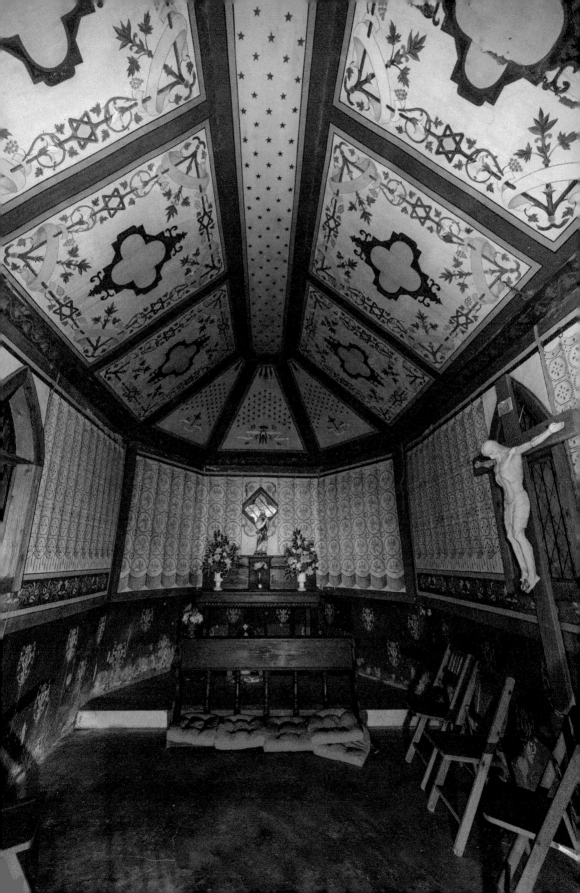

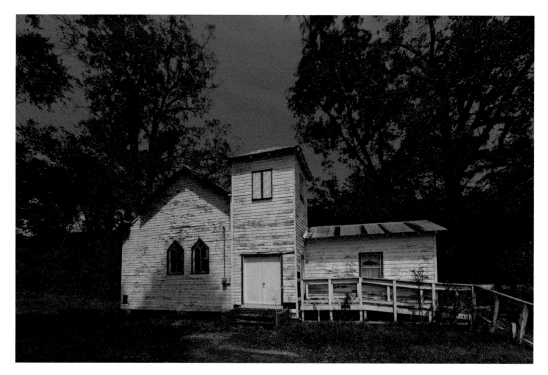

This African Methodist Episcopal church was built in 1890 on a half-acre of former plantation land sold to the congregation by the Platt family for $100.

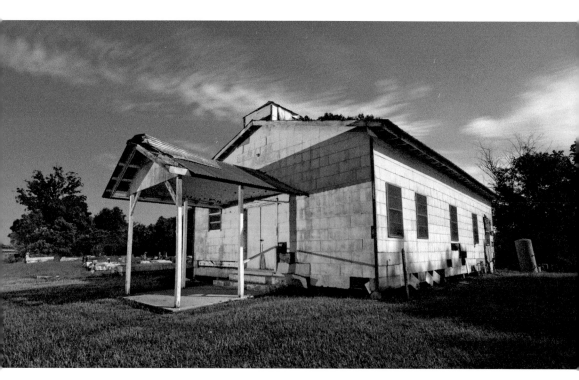

A small wood-frame Baptist church, built in 1893.

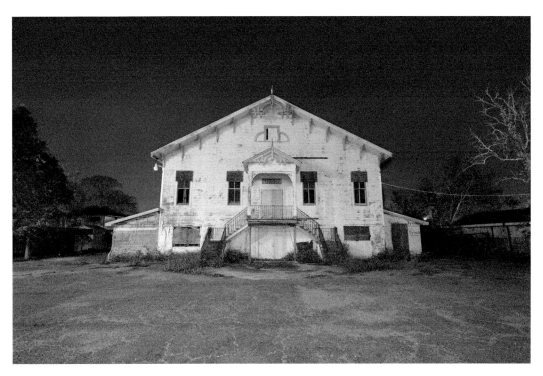

This building was the community center for Our Lady of Lourdes Catholic Church and was shuttered after Hurricane Katrina swept through the area. The dual staircase in front is a common feature of French-style architecture throughout southern Louisiana.

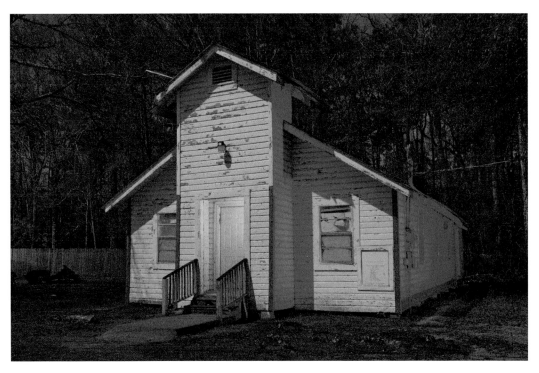

This small community Baptist church was established in 1950.

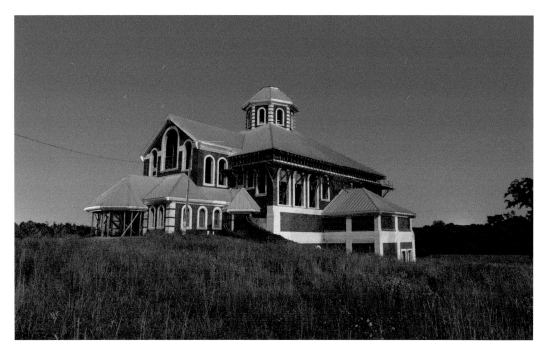

This beautiful Tabernacle Baptist church has remained unfinished for more than twenty years.

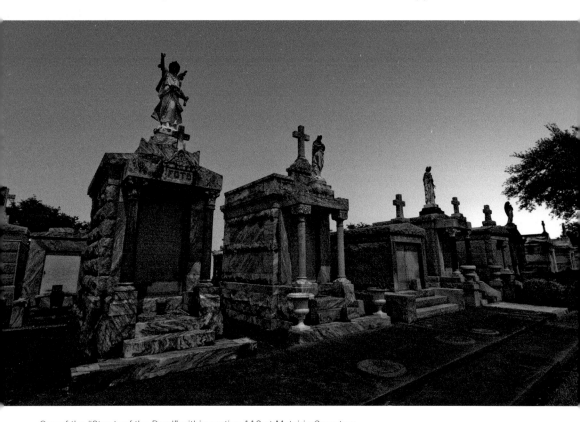

One of the "Streets of the Dead" within section 110 at Metairie Cemetery.

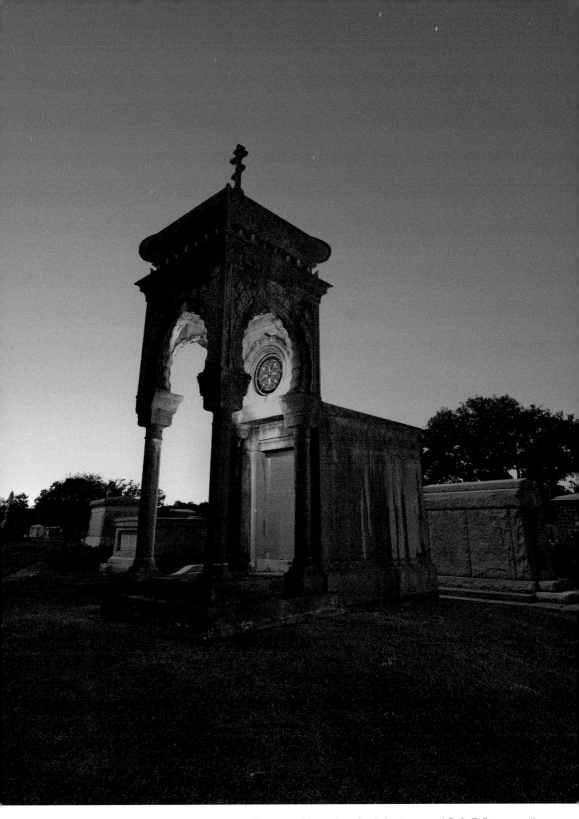

This tomb is the final resting place of Laure Beauregard Larendon, Confederate general P. G. T. Beauregard's favorite daughter. Beauregard oversaw the design and construction of this unusual mosque-style tomb.

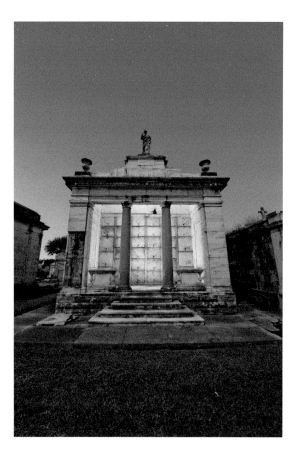

▲ Mausoleum for the Society Italian Di M. B. San Giuseppe; fabricated in Italy and erected onsite in New Orleans in 1857.

▼ This mausoleum has a stained-glass window in the back with a faceless Madonna with child. It is the family tomb for the Marinoni family, one of whom was a 1st lieutenant in the Confederate infantry.

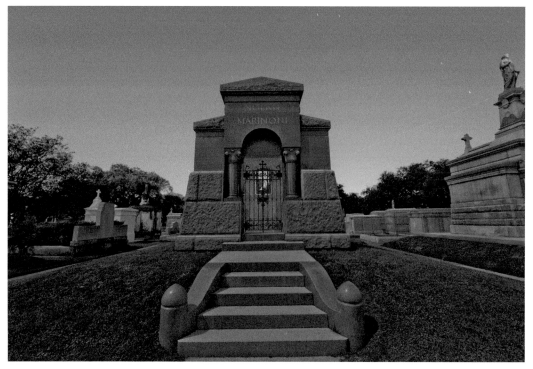

2

THE EVERYTHING STORE

In the early days, a general store was a place where local residents could find a wide variety of merchandise. These stores were predominantly found in rural areas where they also served as major gathering locations for the local community. Some were built to supply the needs for an entire plantation. As time went on, the stores adapted and became more like today's convenience stores with the addition of gas pumps and a Coca Cola machine out front. Very few of these old stores have managed to stay open but their remains can still be found along the back roads and in the small towns across Louisiana. Standing in front of one of these places, late at night with no one around, the faint smell of gas and oil in the air can almost take you back to a simpler time.

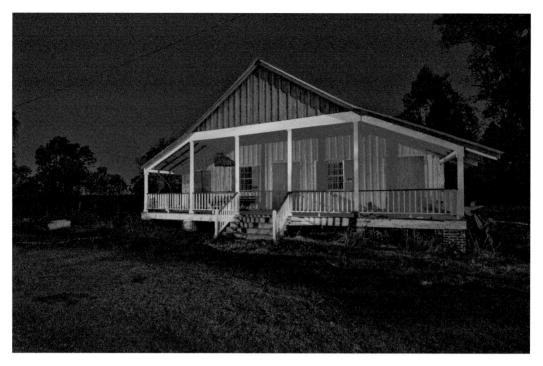

This general store opened in the 1850s as the main general store for the former Orange Grove Plantation, owned by the Devall Family.

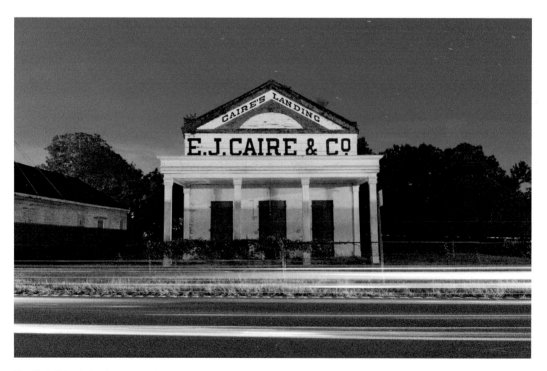

The E. J. Caire & Co. Stores consisted of two buildings on the bank of the Mississippi River overlooking the River Road. They stood next to each other at what was once known as Caire's Landing. This is the older and smaller of the two and was built in about 1855.

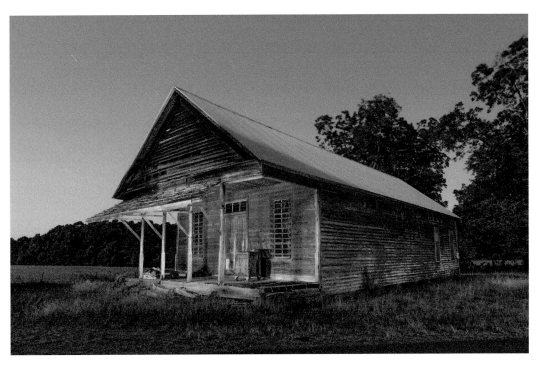

This general merchandise store was established around 1874 by two teenage brothers.

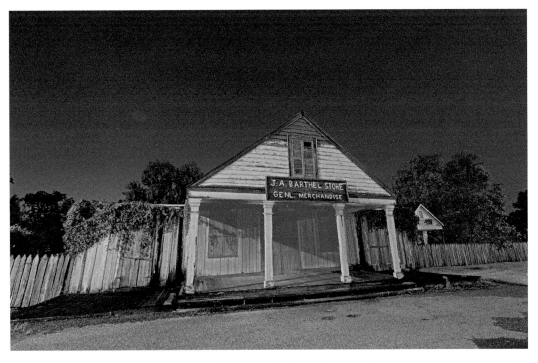

This former general store was built in 1880 in rural East Baton Rouge Parish and carried general merchandise in the front room while offering card games and a barroom in the back.

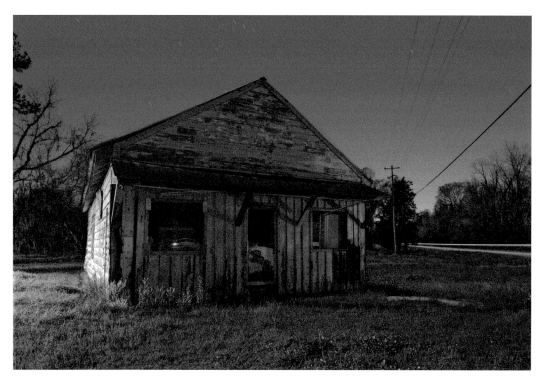

This general store also served as the area post office and was built in 1901.

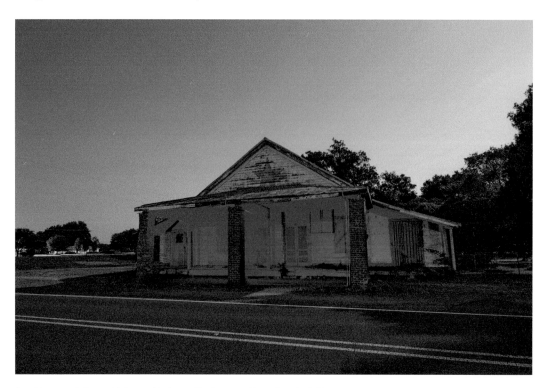

An old general store which provided supplies to several nearby plantations.

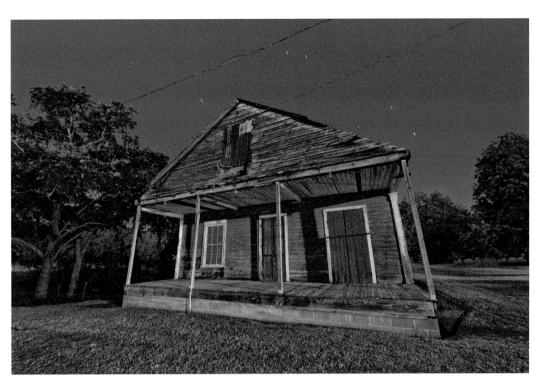

This old general store was built in the early 1900s near False River, Louisiana.

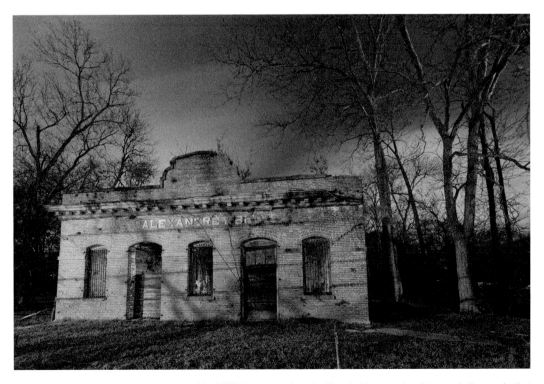

This former general store opened in 1928. It was equipped with a ladder on a track to reach the goods that were stored on high shelves.

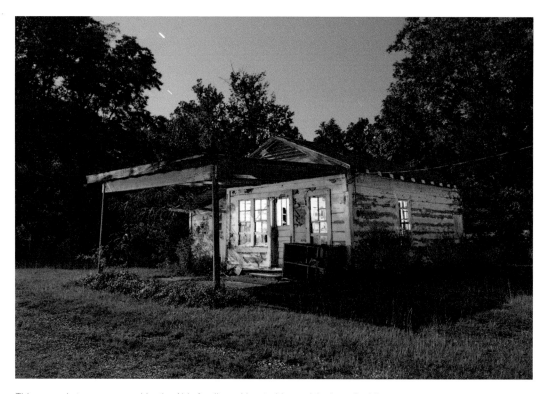

This general store was owned by the Aldy family and located in rural Jackson Parish.

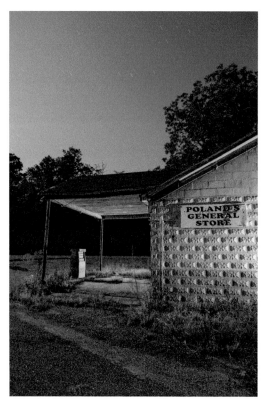

General store owned by the Poland family closed in the mid-2000s.

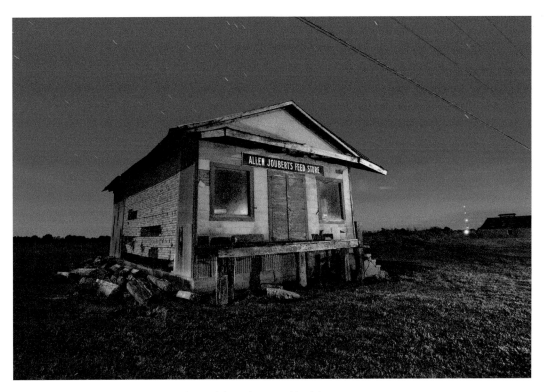

One of many small rural stores located throughout rural Louisiana.

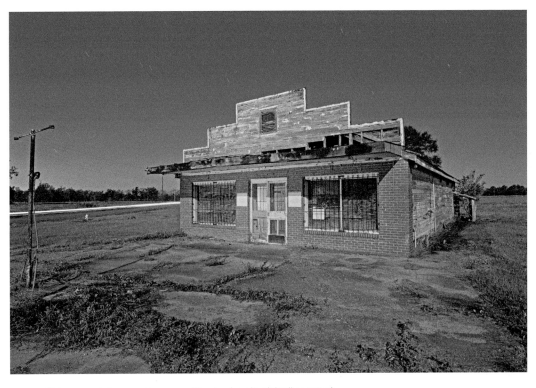

This general store was known as Clem's when it originally opened.

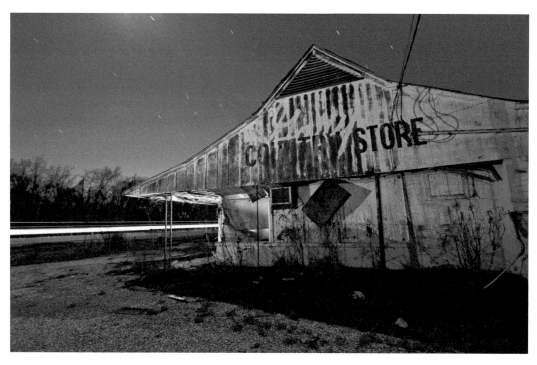

This Stuckey's store closed in the 1980s.

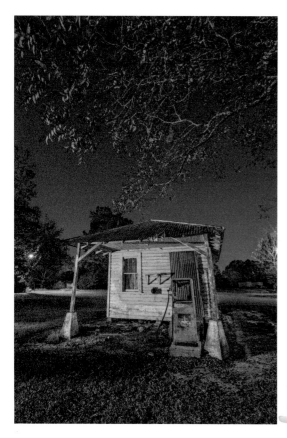

This tiny gas station on a side street was once run by, reportedly, a "sweet lady" named Miss Alberta.

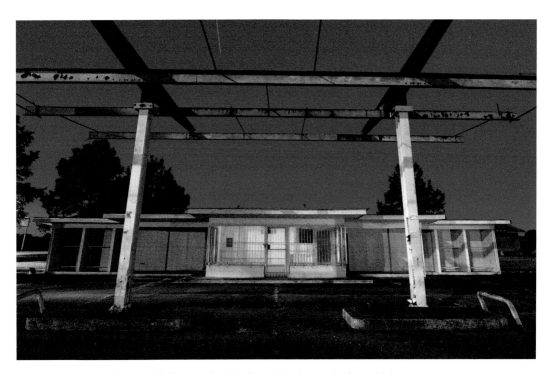

This former full-service Gulf gas station sits along a lonely stretch of state highway.

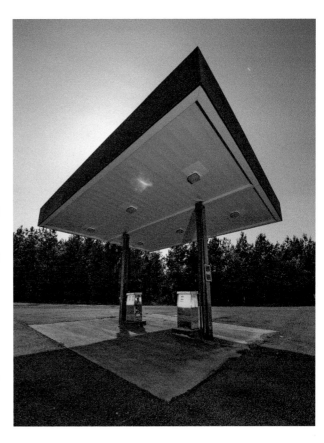

These pumps are all that remain of a second gas station built on this location after the first building burned to the ground. The owner reportedly rebuilt the entire station after the fire rather than paying to have the original gas tanks removed from the ground.

On the following page:
This gas station was formerly owned and operated by Blue Sutton. The pay phone at this station was used by Texas Ranger Frank Hamer to let the world know that Bonnie & Clyde had been shot and killed.

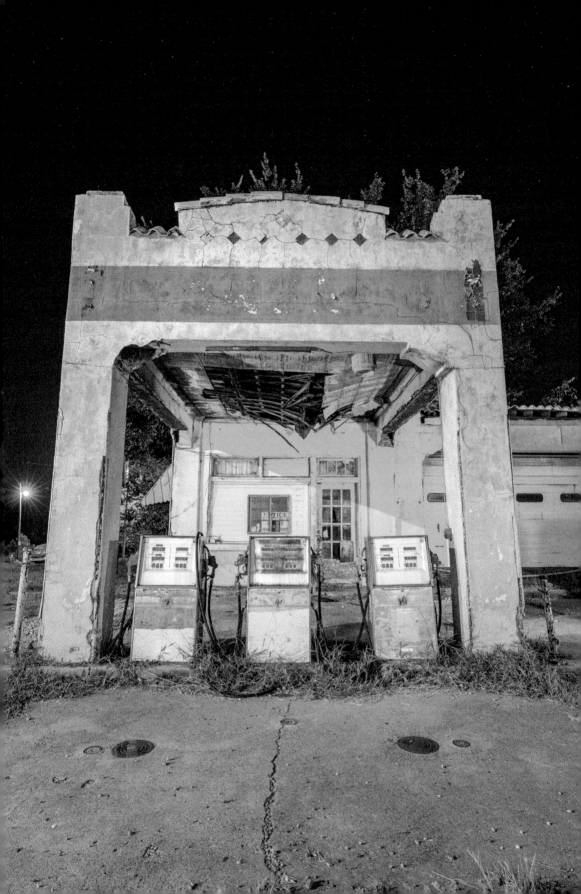

3

HOME SWEET HOME

Houses and homes in Louisiana come in all shapes and sizes. Visitors to Louisiana can find any number of restored grand plantation homes to tour but it is the remaining bits and pieces of these old estates that are the most fascinating. It is not uncommon to find old homesites with nothing remaining except columns or the outline of a foundation. Careful searching around some sites will lead you to a slave cabin where you can stand and silently honor the lives that were lost. Explorers in Louisiana will find countless old shotgun houses and small frame homes dotting the landscape.

Like the churches, many homes of all sizes have been ravaged by floods and hurricanes while still others have burned to the ground. Furthermore, Louisiana's semi-tropical landscape is relentless and any structure left empty quickly becomes overgrown with trees and vegetation. Standing in these old buildings, alone and in the dark, one cannot help but imagine the lives lived and lost.

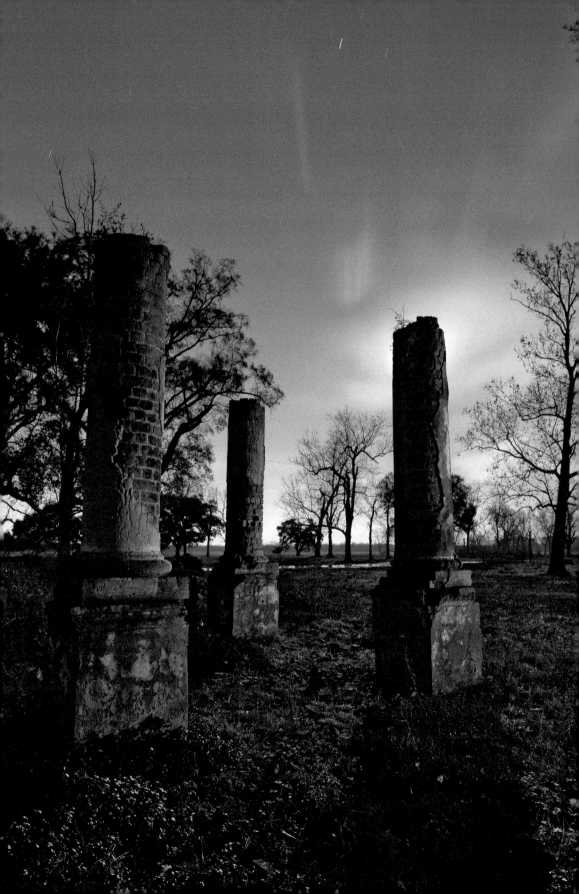

◀ These brick and mortar columns remain as to mark the location of a plantation house built in 1824. When it was built, it had twenty-two rooms and was considered one of the finest in the area. The house survived the Civil War but burned to the ground in February of 1960.

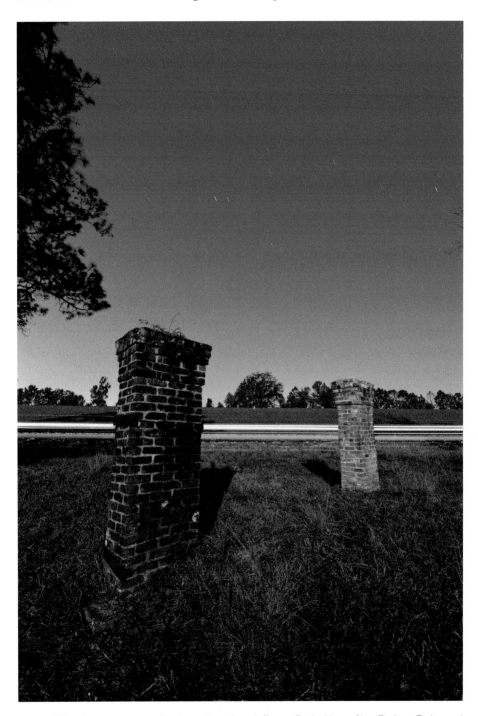

In the 1850s, the owners entertained guests such as Jefferson Davis, Henry Clay, Zachary Taylor, and the Marquis de Lafayette. The plantation was taken over by the Union Army during the Civil War and used as a hospital for soldiers with yellow fever.

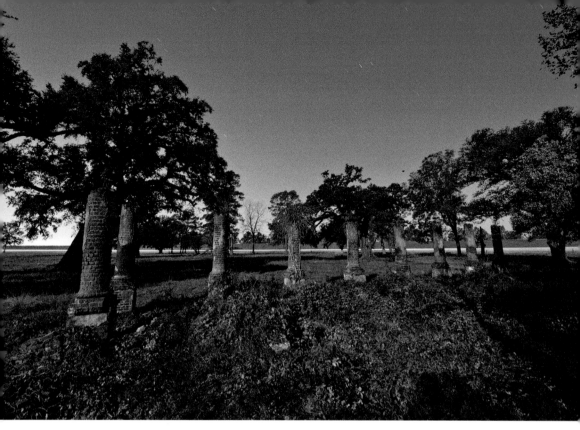

This was the original entrance to the plantation and, along with the columns, are all that survived the 1960 fire.

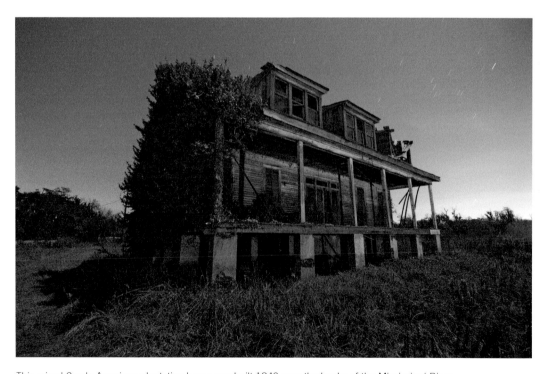

This raised Creole-American plantation home was built 1840 near the banks of the Mississippi River.

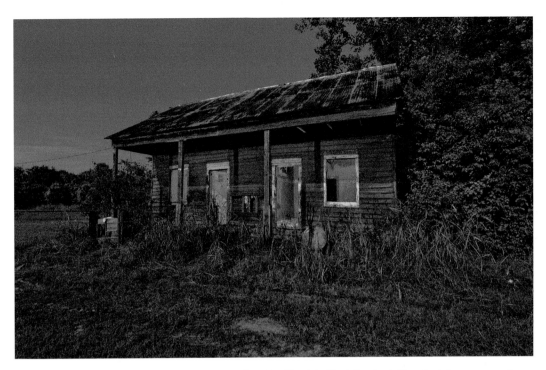

One of a few remaining slave cabins located on the Allendale Plantation land. The plantation was once home to Confederate Louisiana governor Henry Watkins Allen, purchased from Colonel William Nolan in 1852 for $300,000. The house was burned by federal troops during the Civil War.

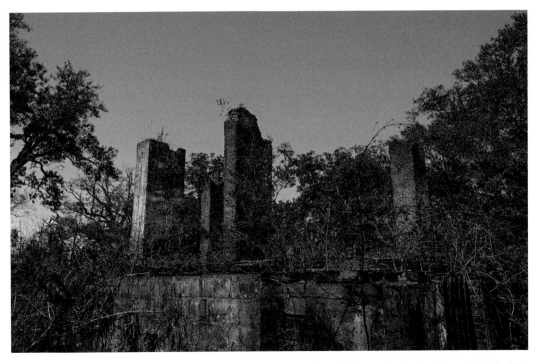

Tezcuco Plantation was a one-story, frame, Greek Revival plantation house located on the east bank of the Mississippi River and built in 1855 for Benjamin Tureaud. It was destroyed in 2002 by a fire.

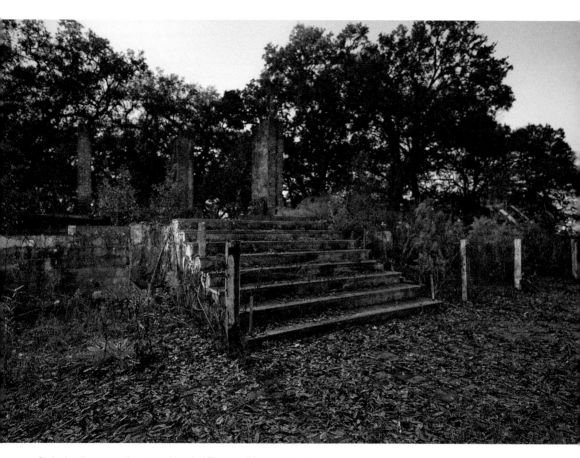

Stairs leading up to the ground level of Tezcuco Plantation house.

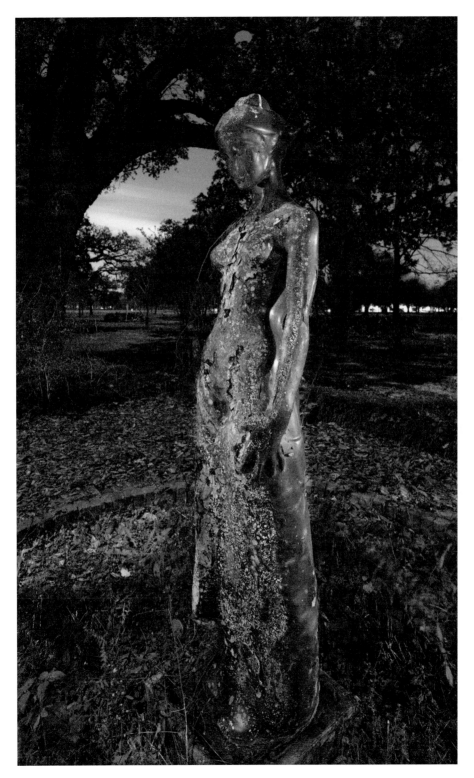

Statue on the grounds of Tezcuco Plantation.

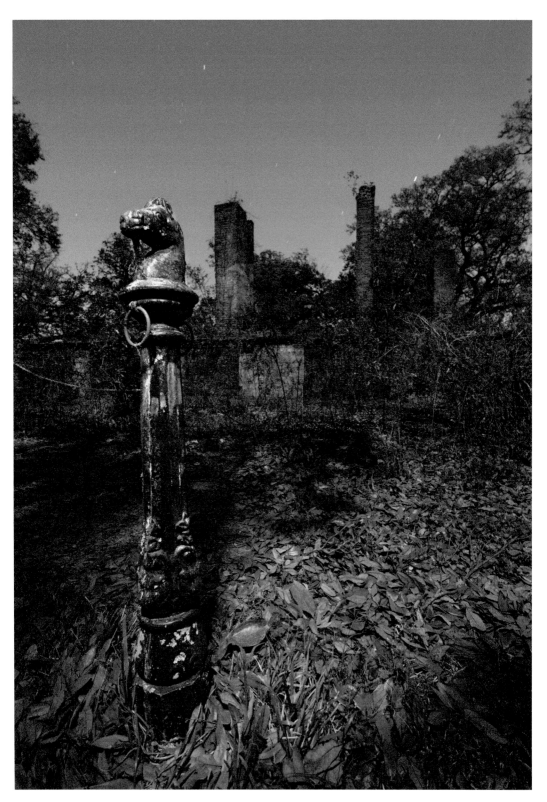

Hitching post in front of Tezcuco Plantation.

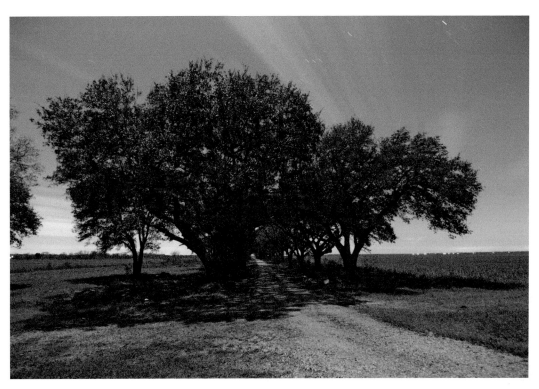

Row of live oaks for an unnamed plantation that once sat along the River Road south of Baton Rouge.

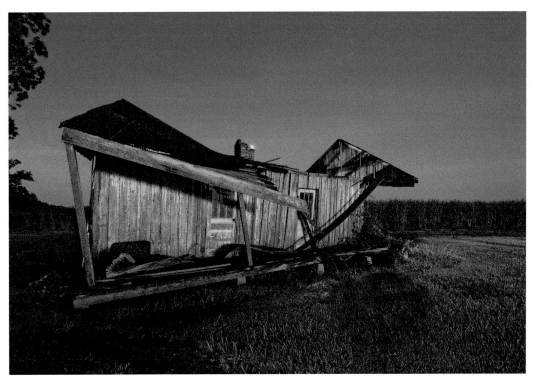

This former slave cabin stands in ruins in an unnamed location

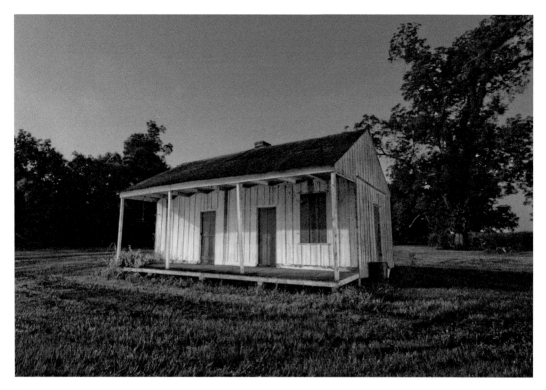

Singular slave cabin in southern Louisiana.

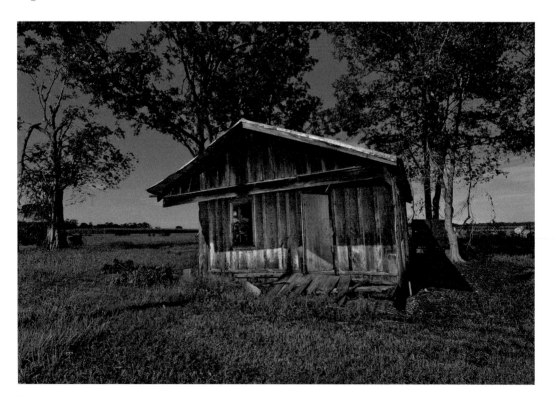

One of two shotgun homes sitting along Bayou Lafourche.

40

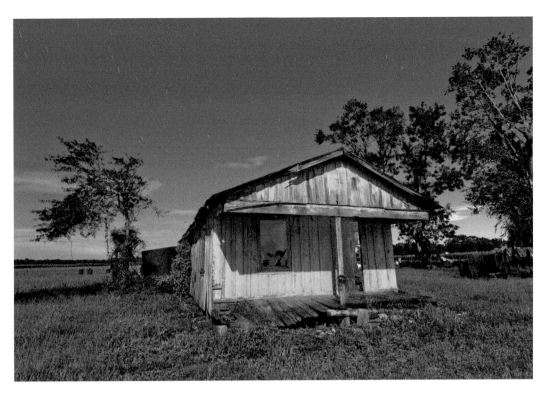

A second shotgun home sitting along Bayou Lafourche.

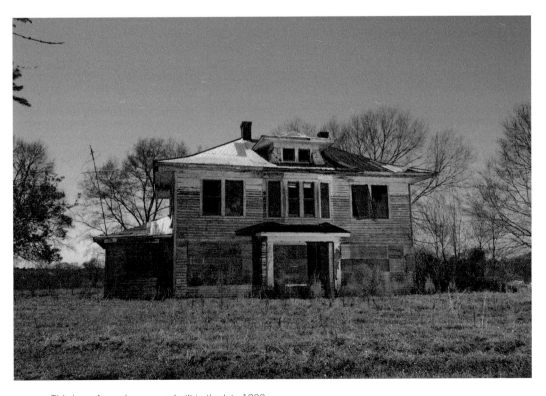

This large frame house was built in the late 1800s.

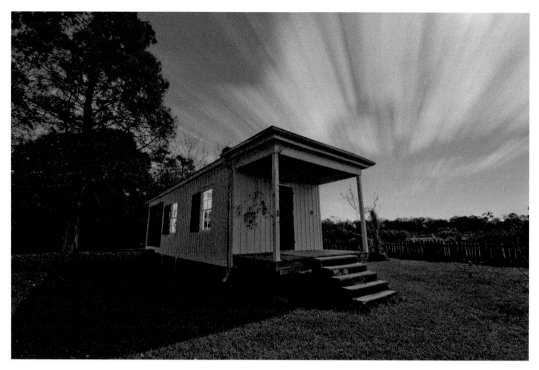

Shotgun house built in the 1800s, probably used by either sharecroppers or tenant farmers.

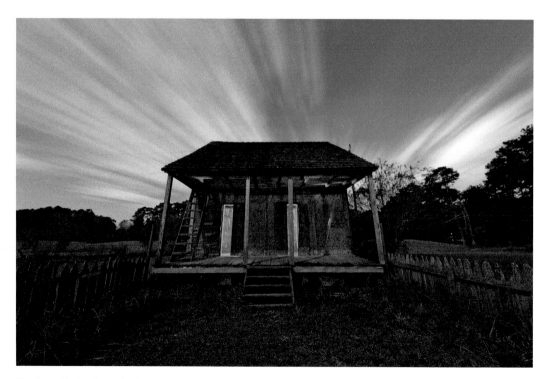

The Jean Charles Germain Bergeron house was built in 1805 and is one of the oldest surviving Acadian houses in Louisiana.

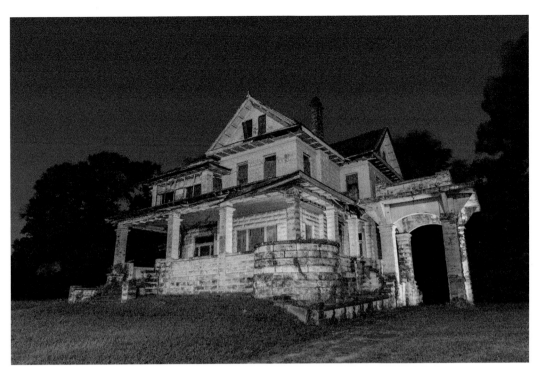

Built in 1885 for the future mayor of Shreveport, it is rumored that there are tunnels under the house leading to a few key locations nearby, such as city hall and the theater.

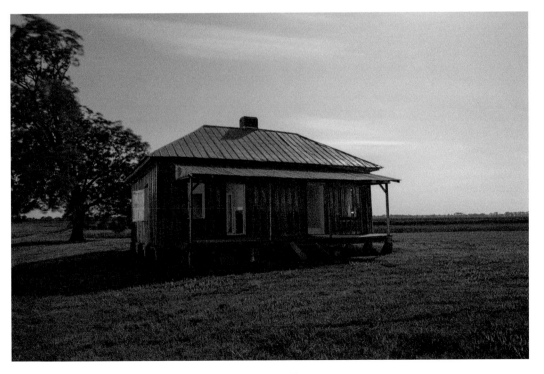

Small cabin from a former plantation established in 1914.

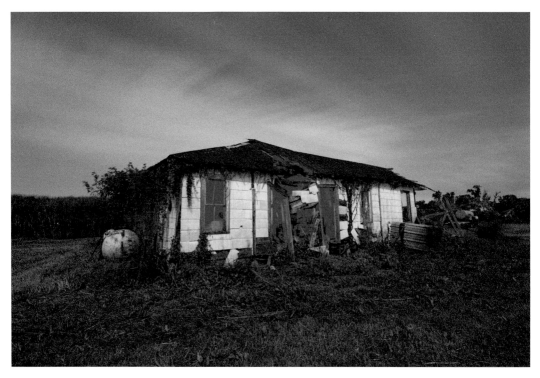

At the end of Munson Road stands a pair of houses that are starting to fall apart. This one has a hot tub and barber chair in the front room.

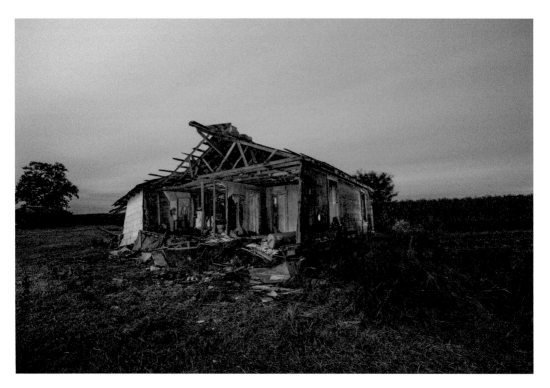

Old forgotten house sitting on a long dirt road surrounded by sugar cane fields.

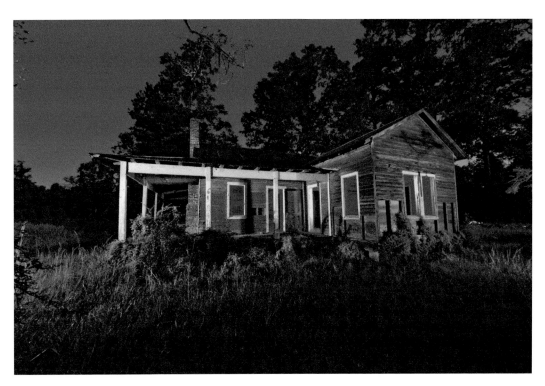

A house tucked back in the trees falling into disrepair. The neighbors use it as a rustic background for family pictures.

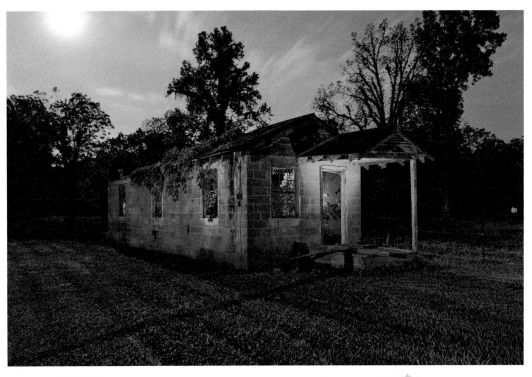

Small shotgun house that's been empty so long it has a small forest growing inside.

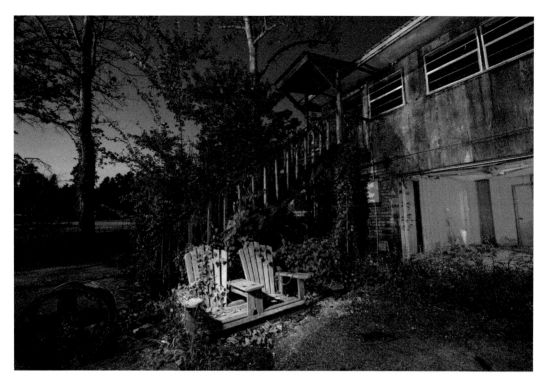

A swing that is missing a porch to hang from.

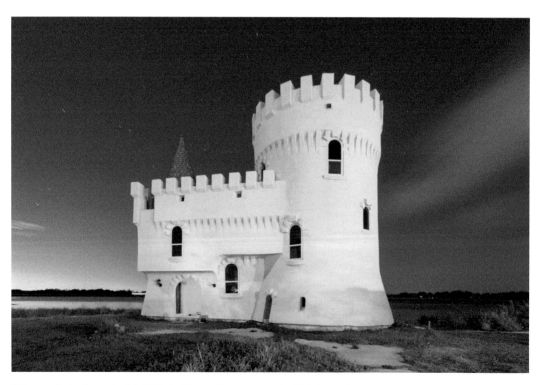

Fisherman's Castle was built in 1981 by Simon Villemarette on the Irish Bayou for the World's Fair. It has survived Hurricanes Katrina and Isaac. It is 942 square feet inside and includes a dungeon.

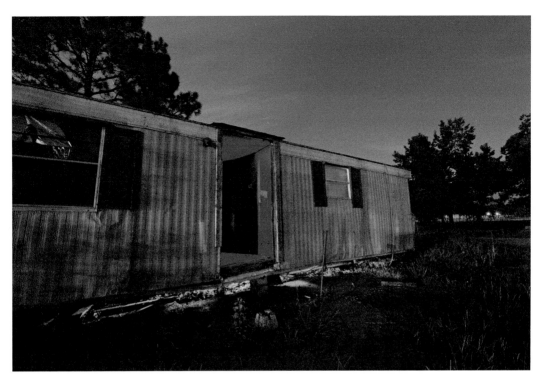

One of a few trailers left in an abandoned trailer park.

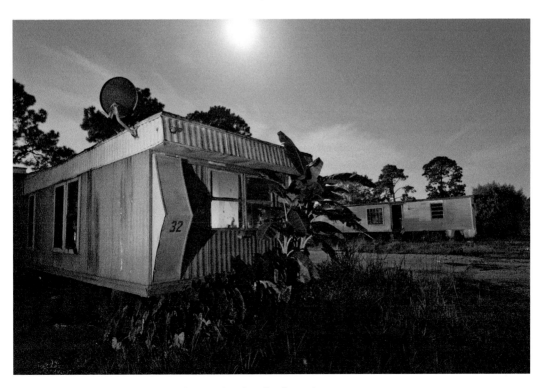

Two of the remaining trailers left in an abandoned trailer park.

4

INDUSTRIAL FAILURES

L ouisiana has a vast array of abandoned industrial sites, from old sugar mills and cotton gins to manufacturing plants and the ever-present oil refineries. Economic challenges and technological developments drove many of these industries to seek new or updated locations and the old sites were often just left behind. Some are being repurposed and others are being entirely dismantled. Some are just left to ruin. Whatever their original purposes and regardless of their futures, these sites give one an insight into a side of Louisiana not often covered in history books or by tour guides.

Cotton gin for a local plantation. ▶

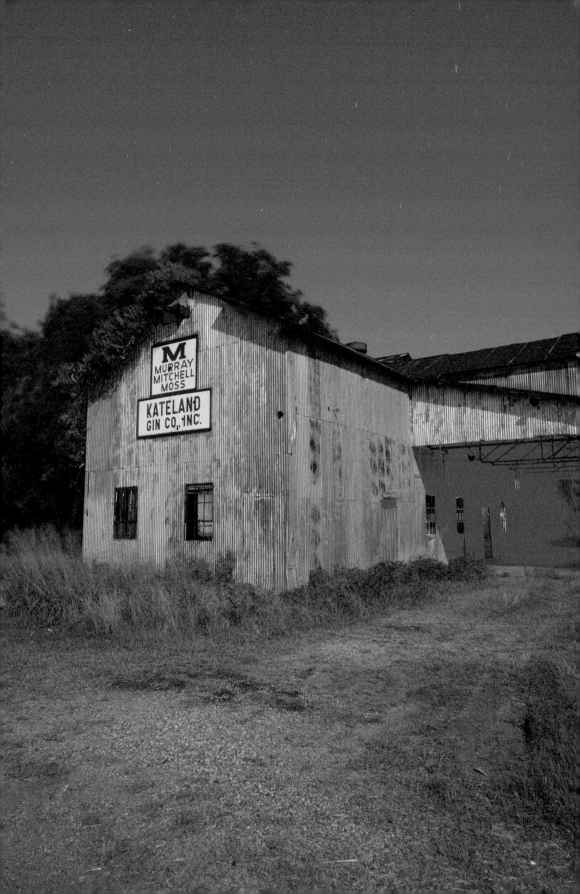

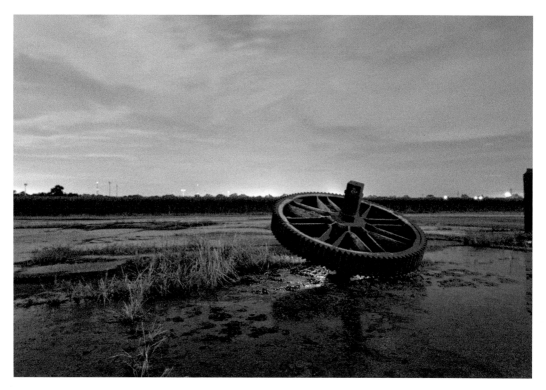

Large gear from partially dismantled sugar processing machinery.

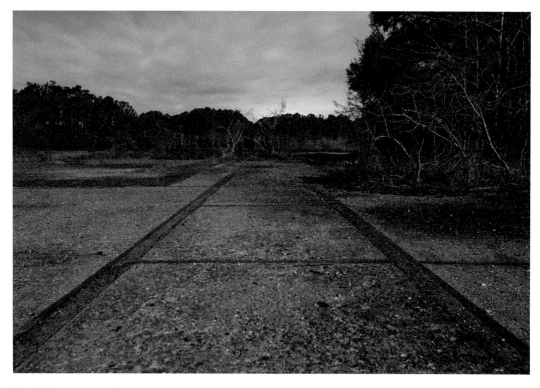

Steel rail tracks leading from a ship building complex to the water for launching.

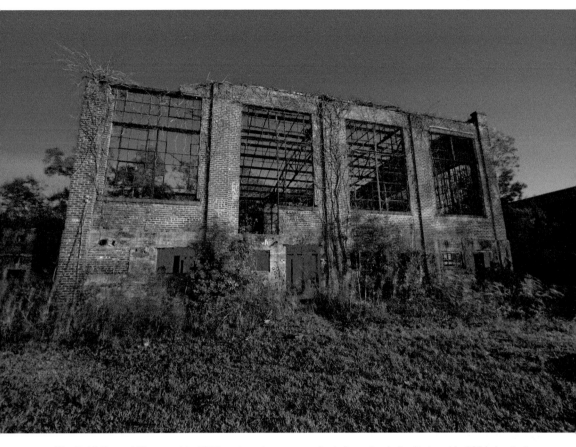

The Boldt Paper Mill opened in 1923 and made paper products from rice hulls. It closed in 1934 due to the Great Depression.

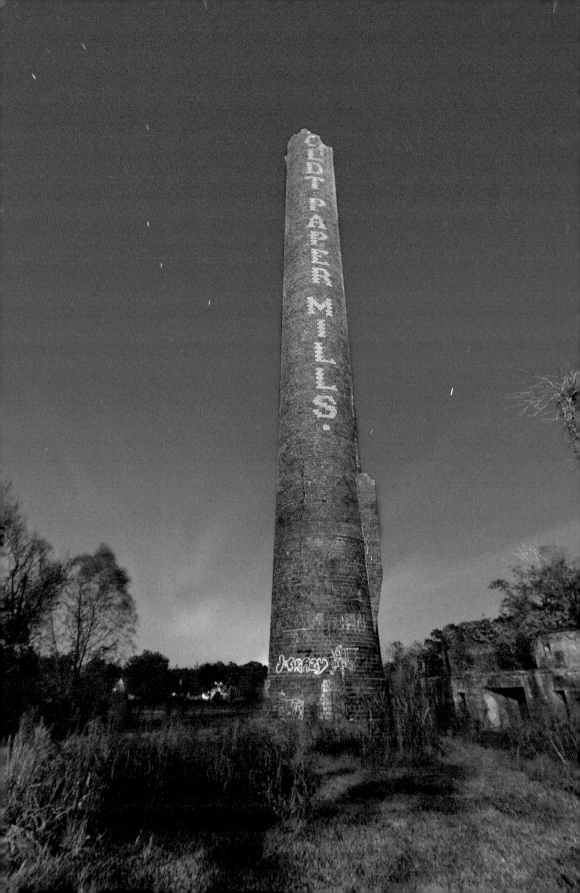

◀ Smokestack for the former Boldt Paper Mill.

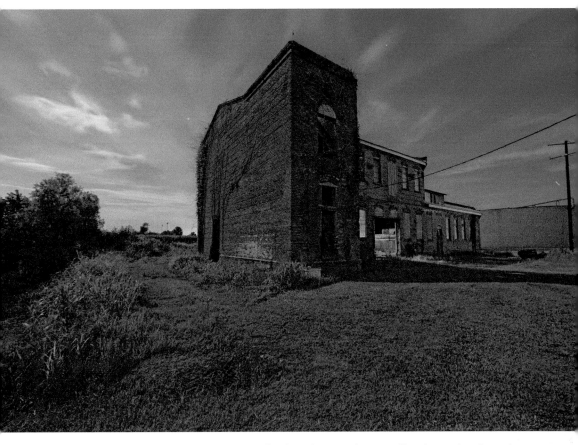

This brick building is located on the property of a plantation-turned-sugar mill and was primarily used as a maintenance shop for the mill.

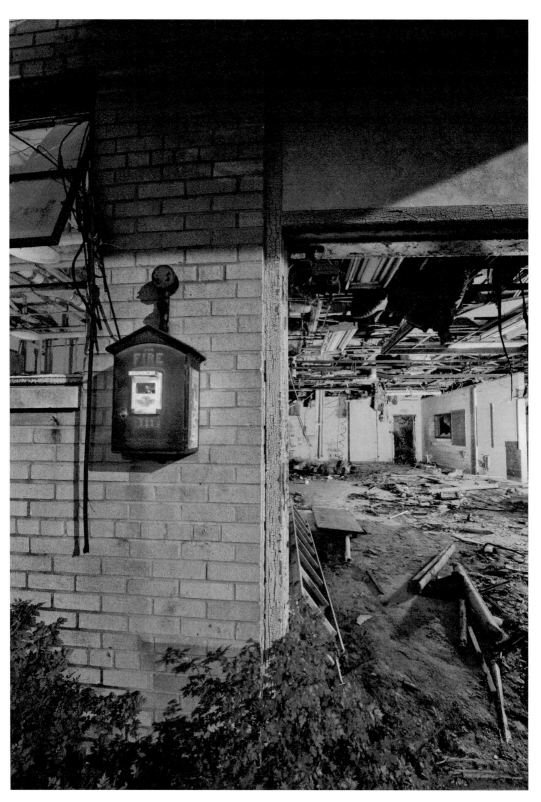

Entrance to tire manufacturing plant laboratory in East Baton Rouge Parish.

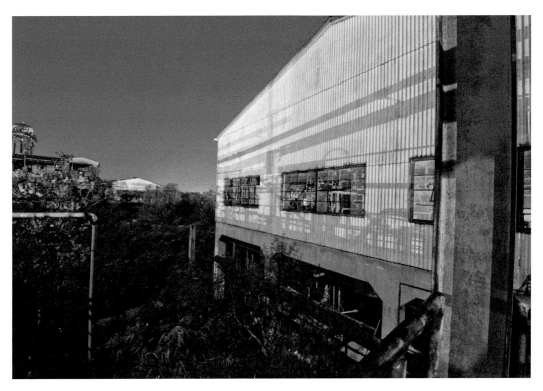

An abandoned tire manufacturing plant.

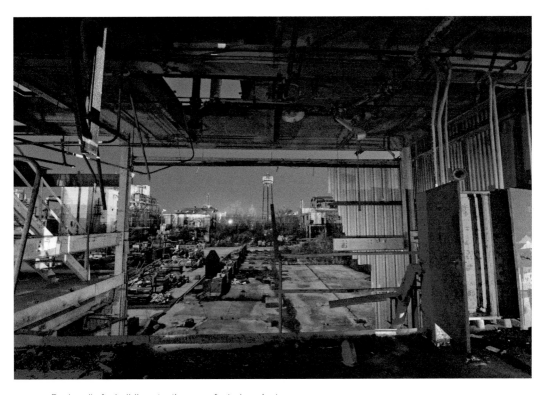

Back wall of a building at a tire manufacturing plant.

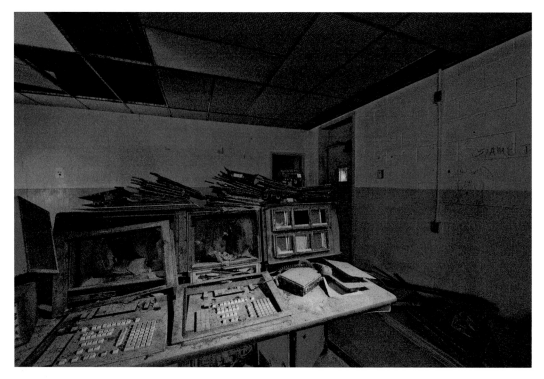

A control panel in the primary control room for vulcanizing tires in an abandoned tire factory.

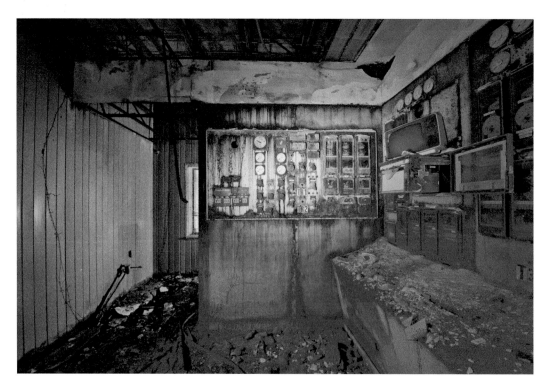

Control panel for a former power plant. The plant closed sometime in the 1970s and sits next to a closed water plant that was built in the late 1930s.

An office on the second floor of the power plant.

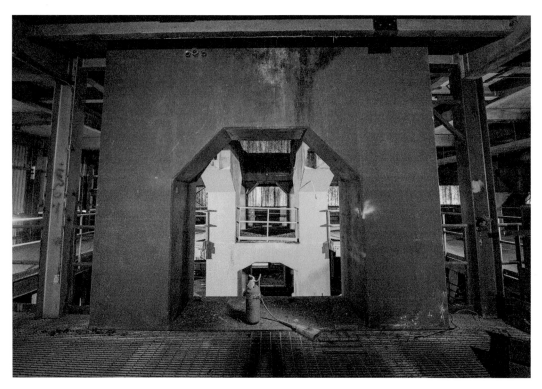

Second-floor generator room for the power plant.

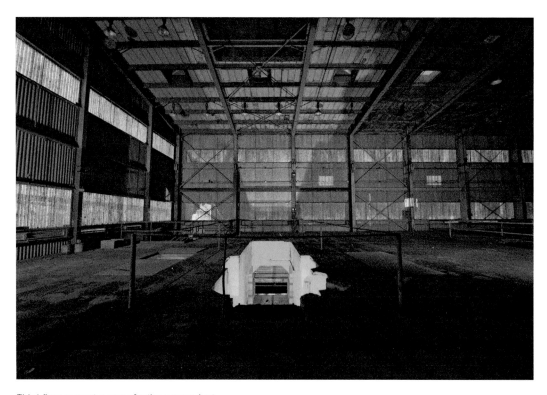

Third-floor generator room for the power plant.

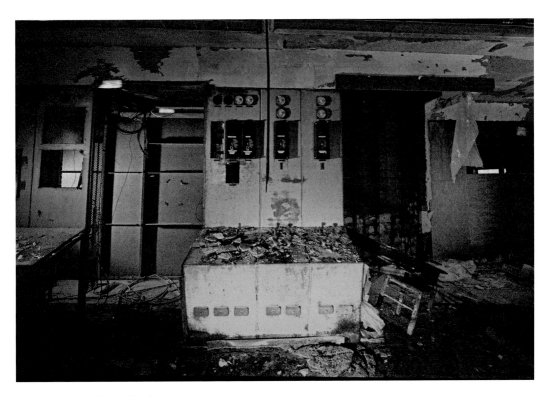

The control panel for the power plant.

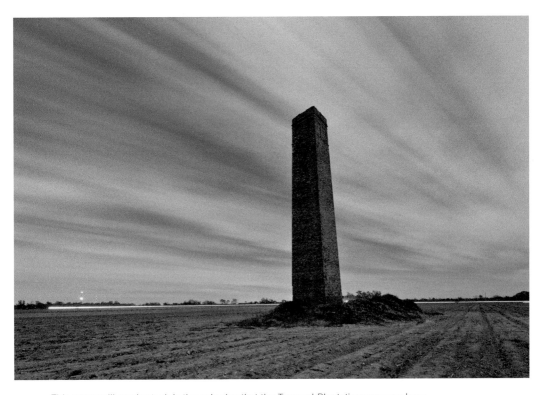

This sugar mill smokestack is the only sign that the Torwood Plantation was ever here.

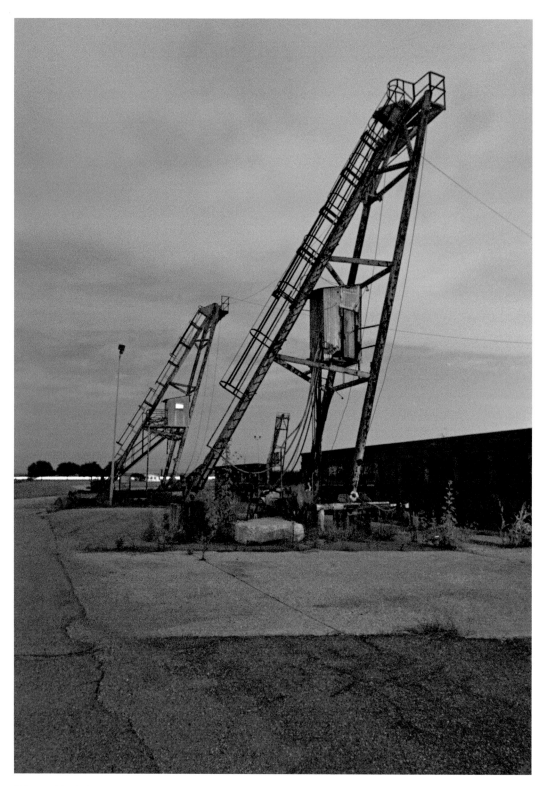

This machine is known as a stiffleg and was used for emptying the cut sugarcane stalks out of the transport trailers into the mill to start processing.

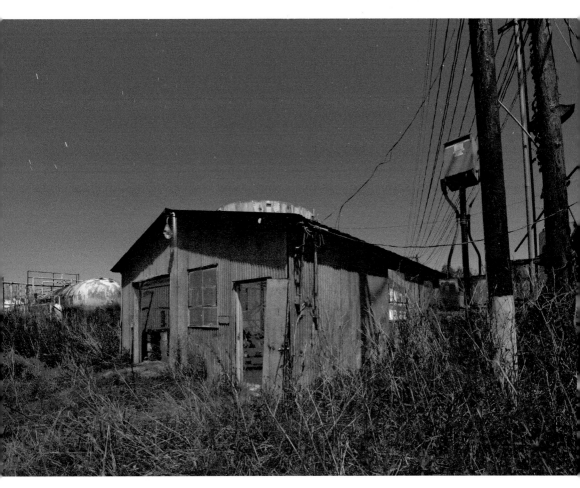

Front of the maintenance shop at a former oil refinery.

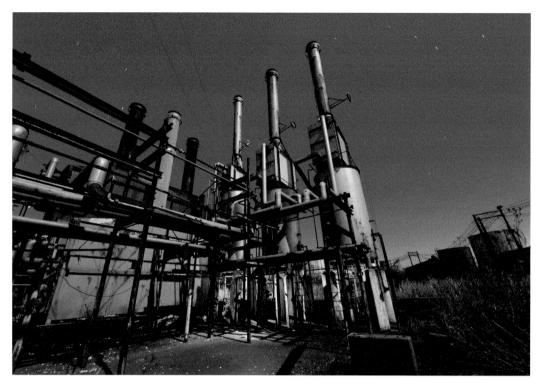

Towers for burning off excess gasses when making fuel at the oil refinery.

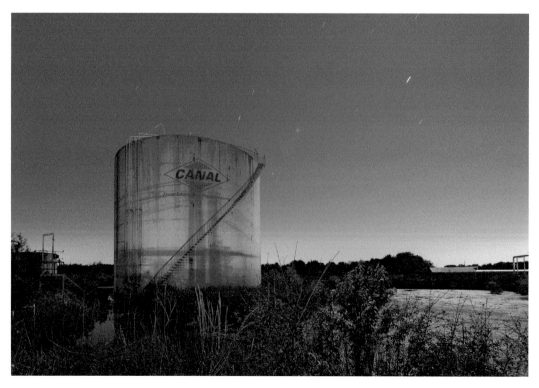

One of many storage tanks at an oil refinery.

5

TRANSPORTATION

By land or by sea: these are the two primary ways for people to get around in Louisiana. Louisiana is one of the few states where the GPS gives travelers an option to use or avoid ferry boats. With so much of the state being covered in water, it's almost a surprise there is not an equal ratio of cars to boats in the state. The state's floods, coupled with relatively low elevation, bring a surprising number of boats onto dry land. And like most areas of the country, cars and trucks end up forgotten and left to the elements in fields and junkyards. Some look much like they did when they were still being used and others have found second lives as advertising signs or restaurants. And sometimes, they simply sit long enough in one place that they fall apart or are overtaken by nature.

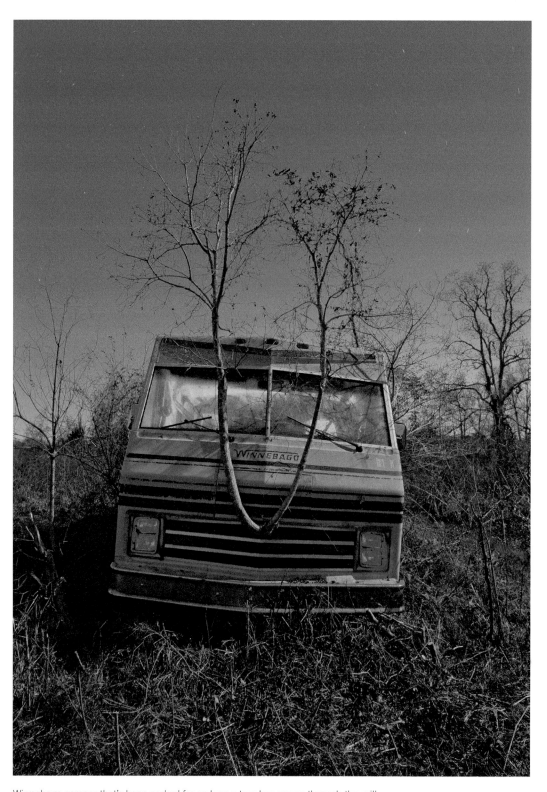

Winnebago camper that's been parked for so long a tree has grown through the grill.

What's left of a 1970s-era Corvette.

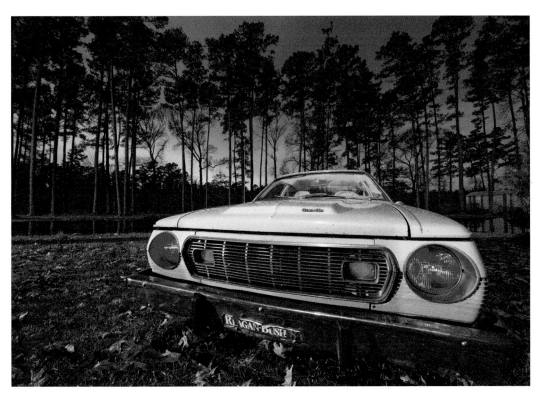

This '74 Gremlin is a genuine little old lady car has 82k miles with factory air and an original bumper sticker from the '84 presidential election.

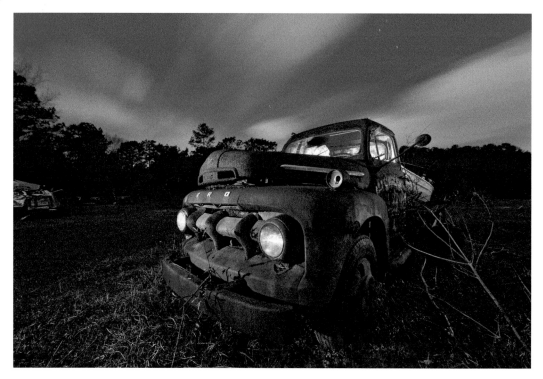

A 1951 Ford tow truck in a junkyard.

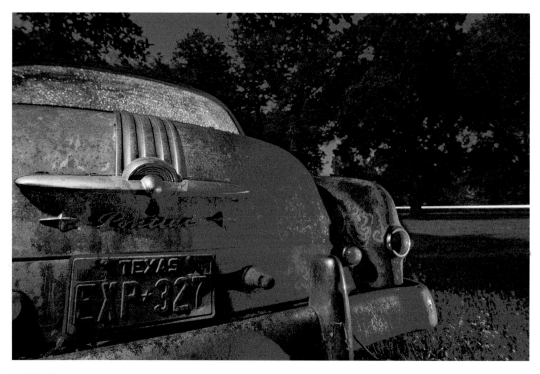

A 1951 Pontiac.

Dodge conversion van sitting in a junkyard. ▶

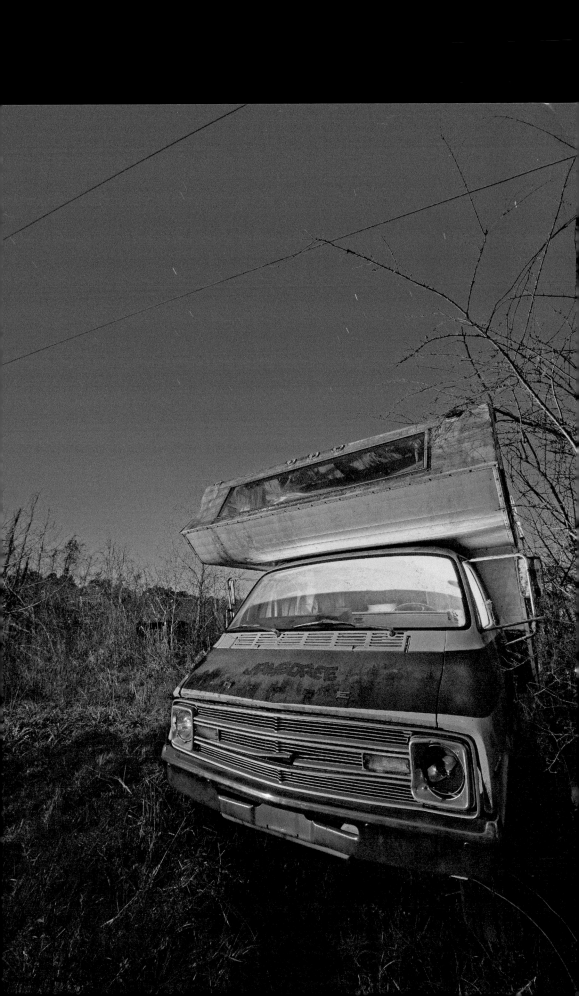

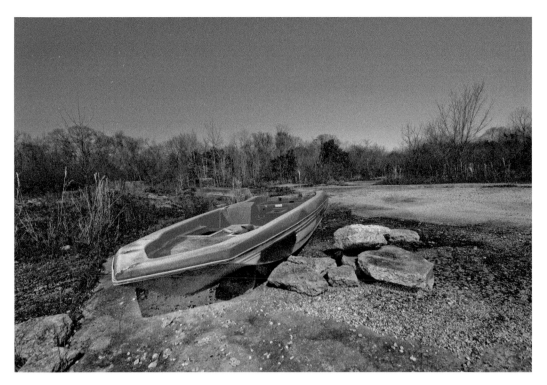

A boat without water.

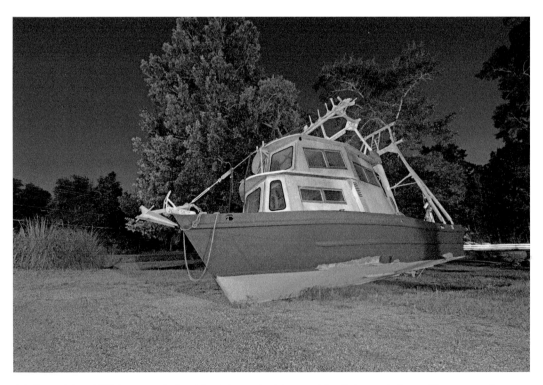

John's much-loved '36 Jersey made four trips between Louisiana and the Bahamas before getting swamped during the Flood of 2016.

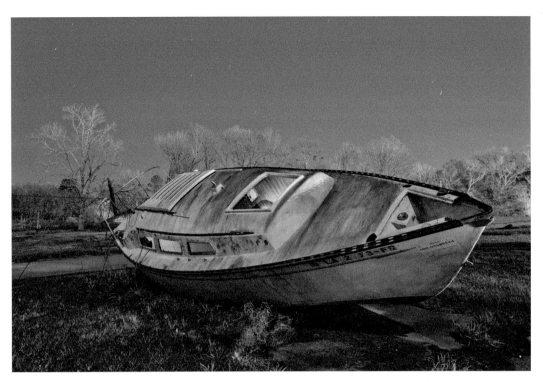

This boat was sitting in the middle of a mobile home park off Airline Highway in Baton Rouge.

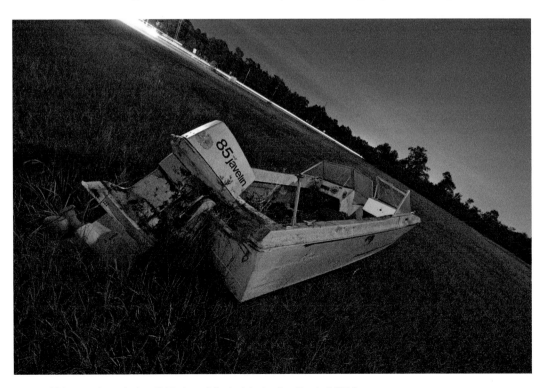

This motorboat sits in a field where it floated during the Flood of 2016.

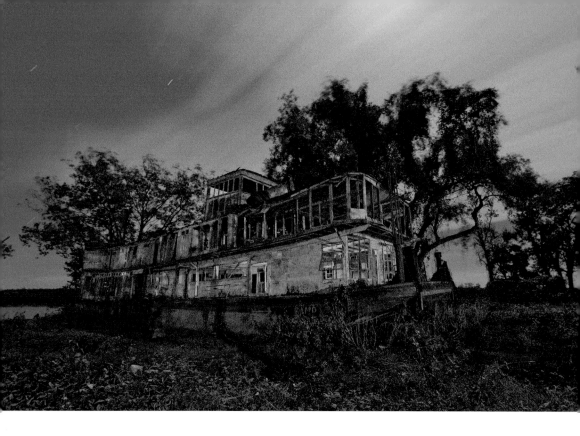

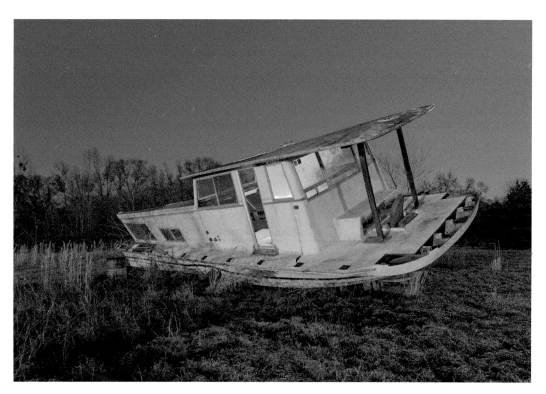

This boat sits in the middle of a field after plans for a seafood restaurant fell apart.

◀ The *Mamie S. Barrett* was built in 1921. It served as President Franklin D. Roosevelt's Mississippi River headquarters during World War II and was later decommissioned. During the Great Flood of 1993, the boat was carried from Natchez, Mississippi, and beached in an unnamed location near the Mississippi River in Louisiana. Various plans to turn it into a restaurant or a casino never came to fruition and it was heavily damaged by fire in 2017.

This boat sits in an empty lot near Baton Rouge.

6

RECREATIONAL ACTIVITIES

We all have things we like to do in our spare time for relaxation. It might be going to a movie, golfing, visiting an amusement park, or taking in a ball game. The cities and small towns of Louisiana are full of the remains of these activities. Old baseball fields sit empty, the last games just a memory. A large golf resort is nothing but a shell, the pool and cabana empty. A large, brightly-colored water park sits, waiting to open. Locations such as these offer a window into the everyday life of Louisiana's residents in a new and unique manner.

Sign for a once popular theater in Baton Rouge that opened in 1961 and closed in 2004; local resident and actor John Schneider later rescued the sign from destruction ▶

BROADMOOR THEATRE

92 4820

THEATRE
TREASURES

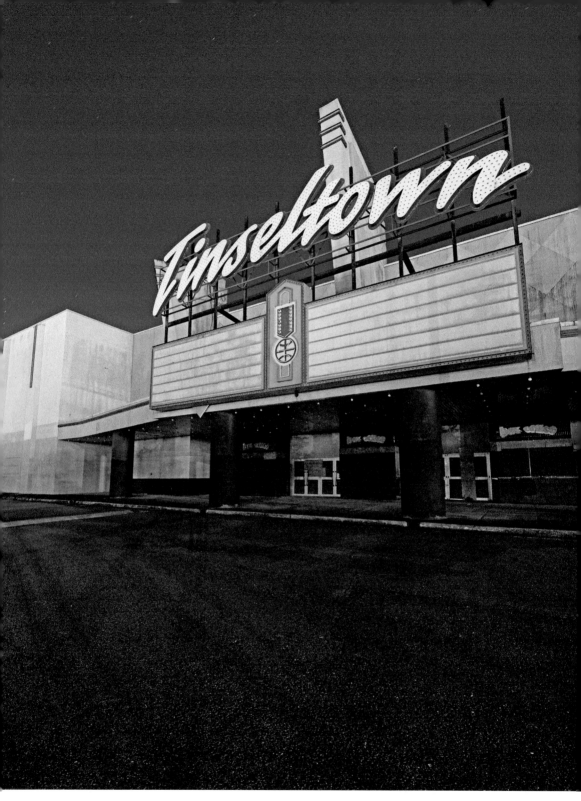

This theater opened in 1996 in a fantastic location and was possibly the most popular theater in Baton Rouge. In March of 1997, a murder for hire occurred in the parking lot. Ticket sales dropped right away, and the theater closed quite soon.

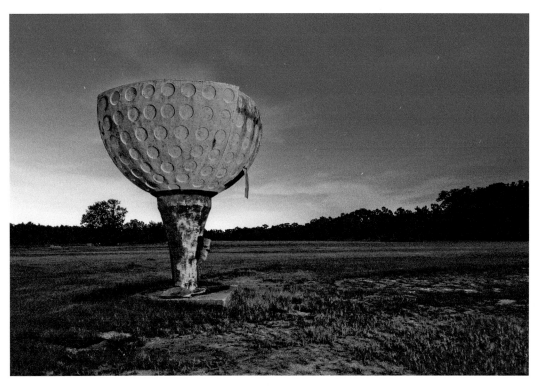

Advertisement for a long-defunct driving range.

Third-base dugout of an unused baseball field.

Bathrooms on the backside of the concession stand at a youth baseball field.

Bleachers sitting along the 3rd base line of a youth baseball field.

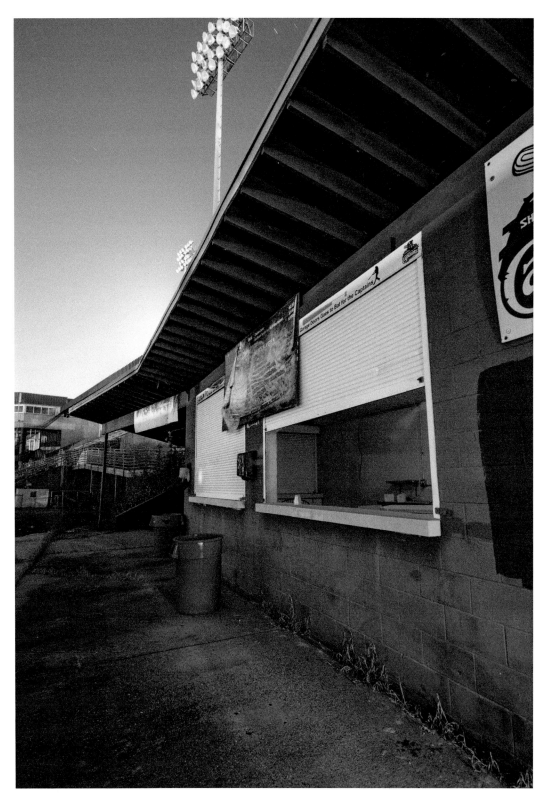

Concession stands for the former Shreveport Captains minor league baseball team.

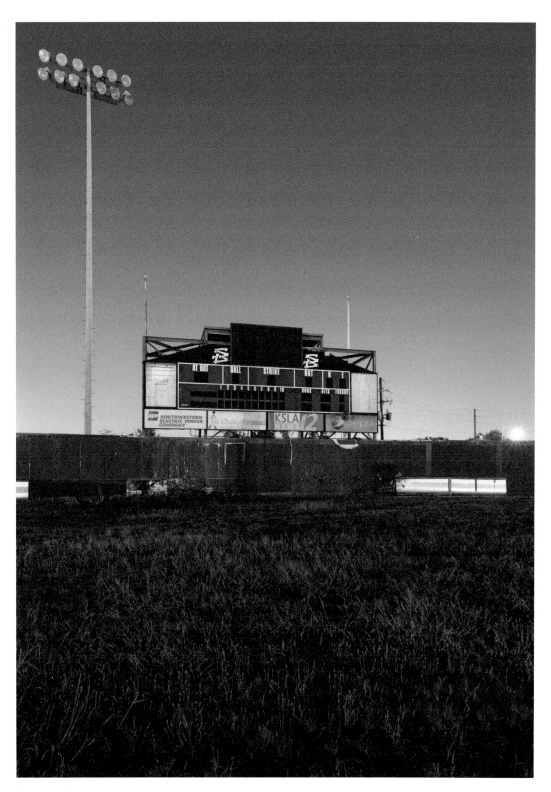

Shreveport Captains' scoreboard.

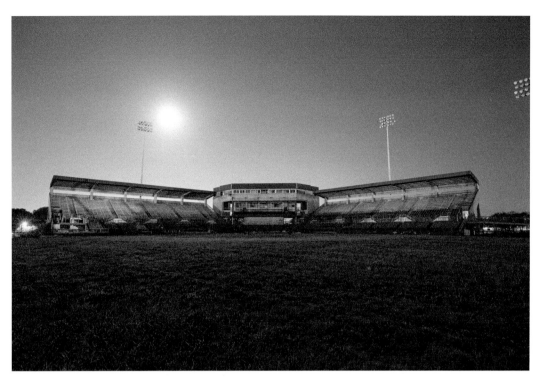

The heat and humidity of the long Shreveport summer made these air-conditioned luxury boxes very popular.

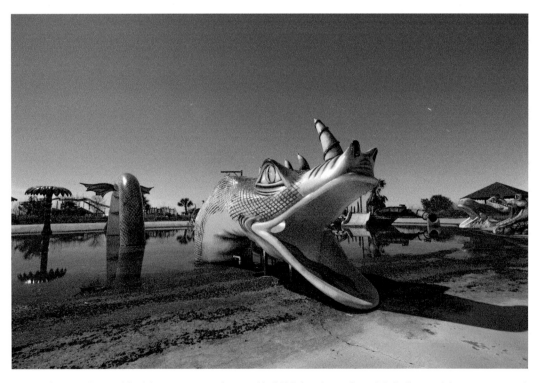

Construction on this elaborate water park started in 2010, but due to financial challenges, it has never opened. This serpent is one of the many water features at the zero-depth entry kiddie pool.

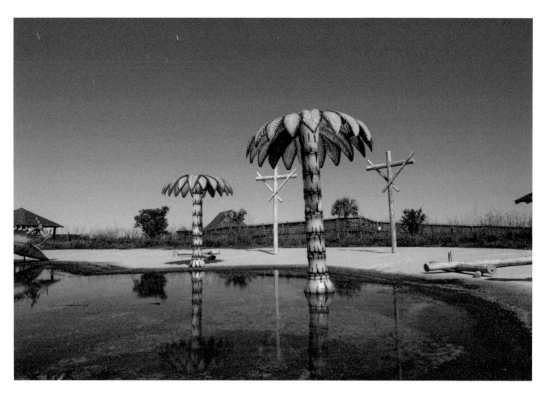

Two of the many palm trees that decorate the kiddie pool.

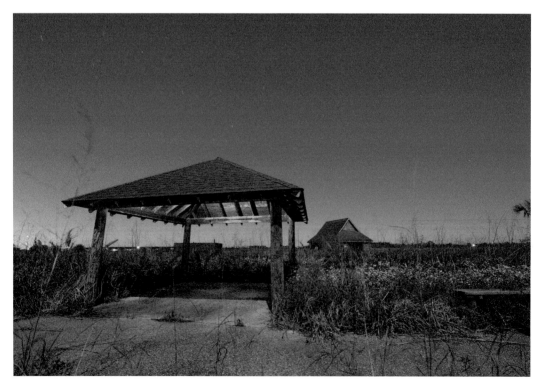

A cabana located between the kiddie pool and the lazy river.

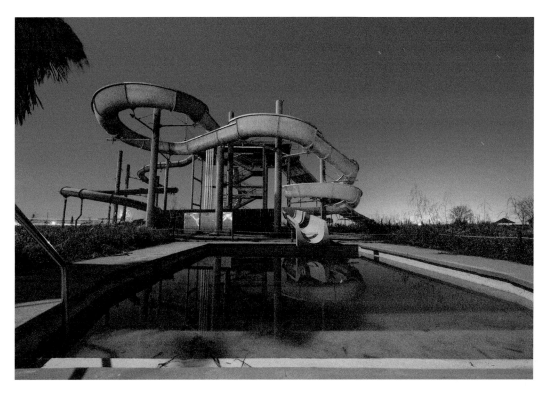

The main tower from which all slides in the water park start.

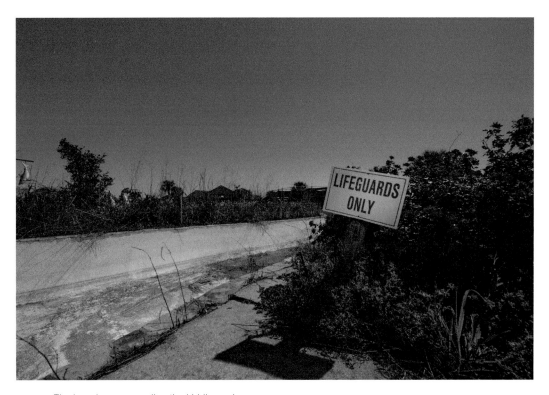

The lazy river surrounding the kiddie pool.

7

HOME AWAY FROM HOME

Abandoned hotels and restaurants dot the backroads of Louisiana and are found in cities and towns of all sizes. Maybe a new highway bypass was constructed or maybe it was just the changing needs of travelers. Sometimes a place looks like the last person checked out that morning, locked the door, and then walked away leaving behind a place frozen in time. Other times, there is barely any sign of what used to be there beyond the remains of a foundation, a sign by the street, or a nearly unnoticeable set of tiles marking the sidewalk. Regardless of the reason or what is left, these old places offer a fascinating glimpse into days gone by.

Road sign for old motel near St. Francisville. ▶

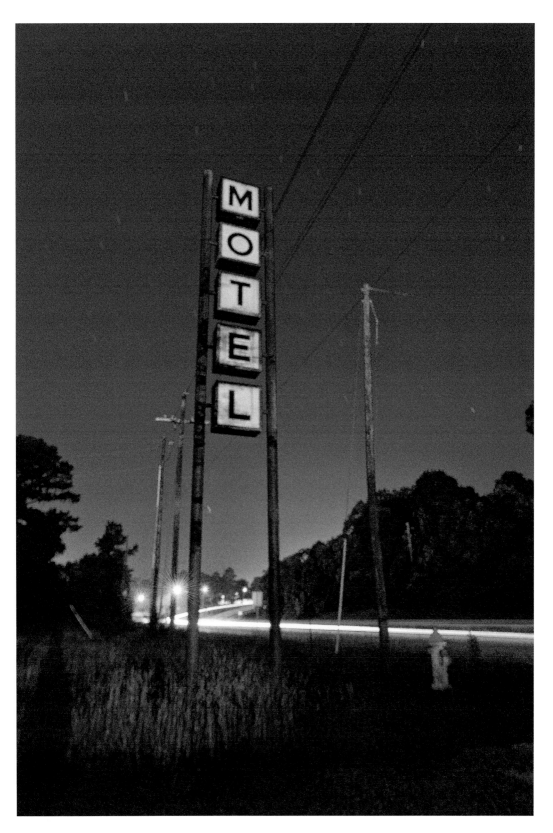

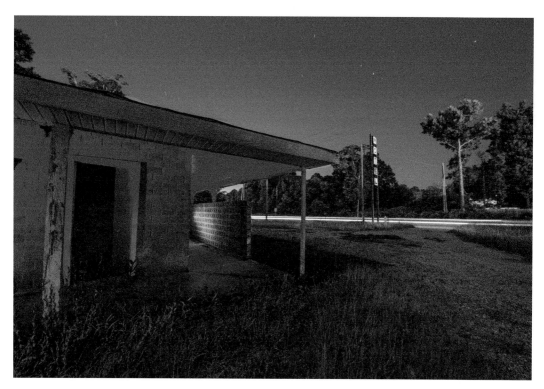

Front corner of a motel near St. Francisville. No sign for an office, no office; just rooms and beds.

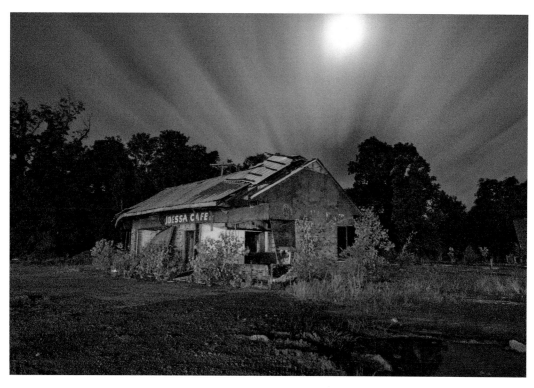

A cafe well-known throughout the central part of Louisiana for having the best biscuits around.

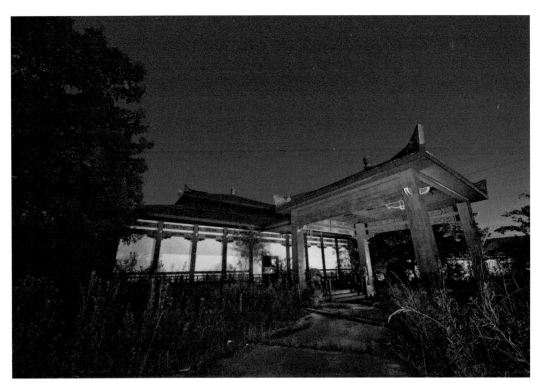

Former Chinese restaurant waiting for a new owner.

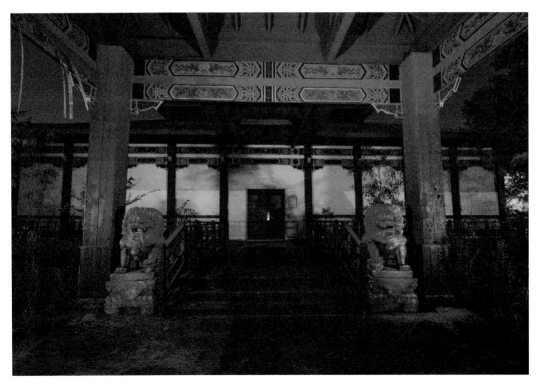

Entryway of a former Chinese restaurant that has been sitting empty for several years.

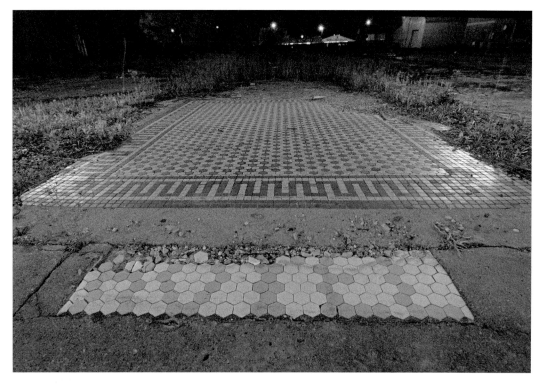

Front tile entryway for the former Newman Hotel.

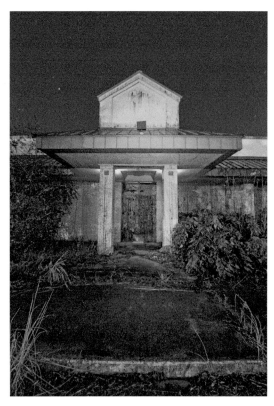

Boarded-up doorway leading into the bar of a long-empty Ramada Inn.

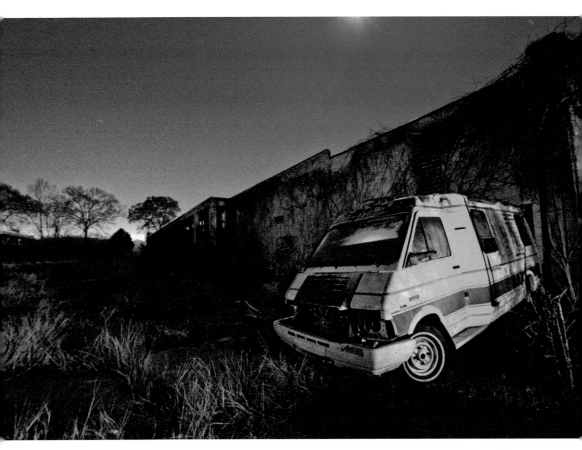

This RV was abandoned behind the empty Ramada Inn.

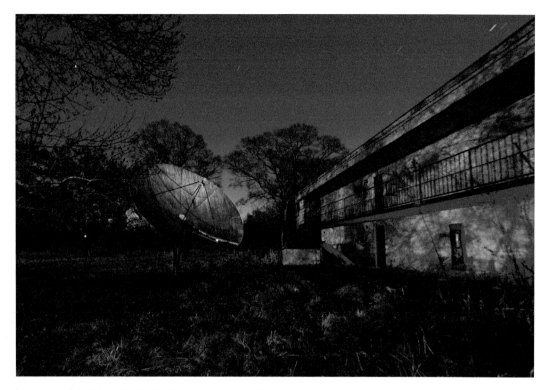

Unused satellite dish on the back side of a long-closed Ramada Inn.

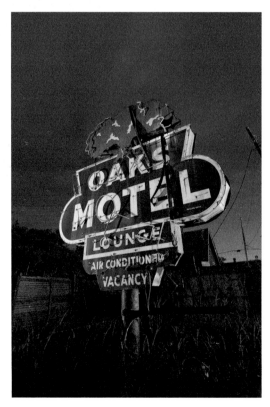

This sign is the only thing remaining of a motel and lounge that was built in the 1950s. When it was still operating, the lounge was open twenty-four hours a day.

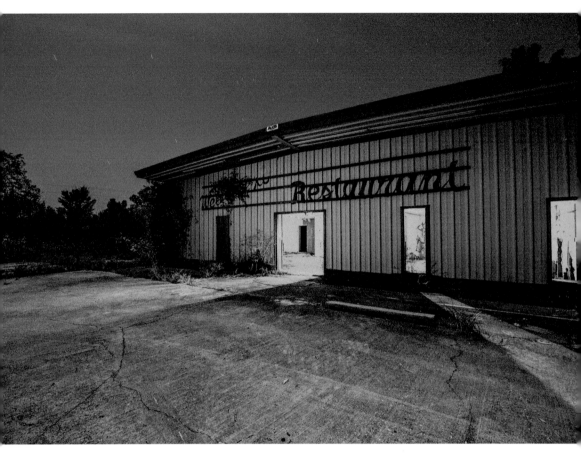

This former restaurant closed down at the beginning of the twenty-first century; they reportedly did serve "good hamburgers."

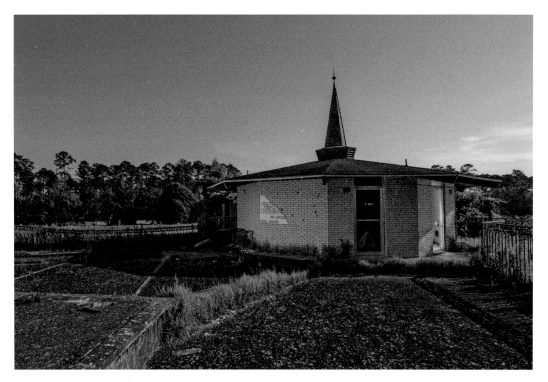

Emerald Hills Golf Resort opened in 1970 and closed in 2011. Combination bathroom and changing room for the swimming pool at the resort.

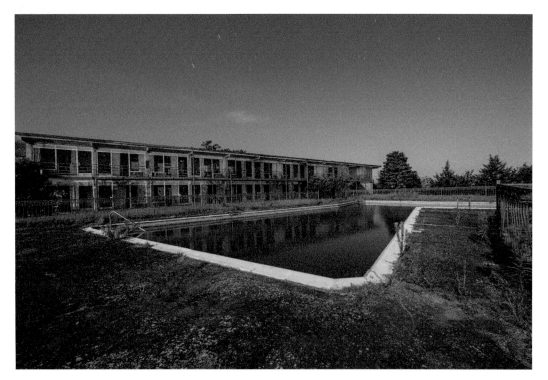

Poolside view at Emerald Hills.

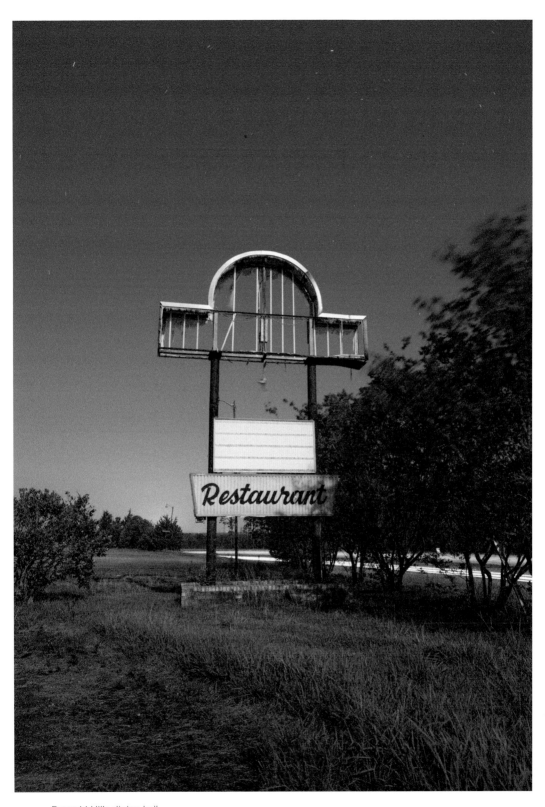

Emerald Hills dining hall.

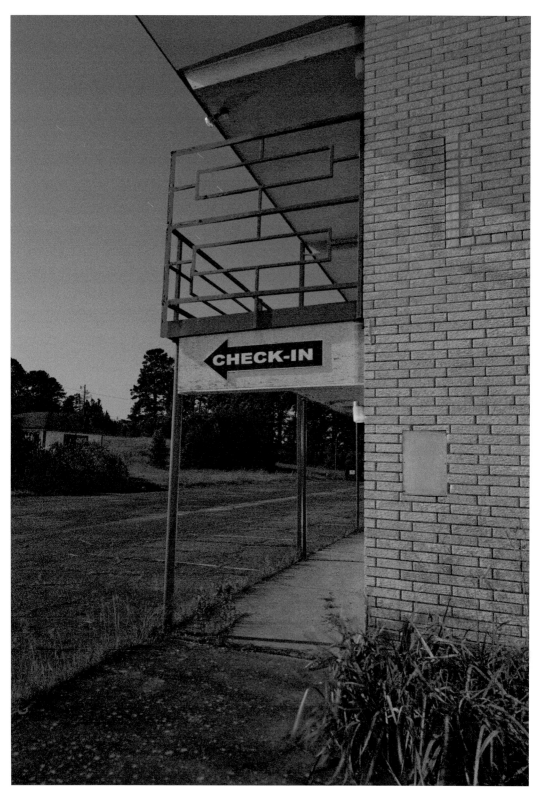

Near the entry of Emerald Hills.

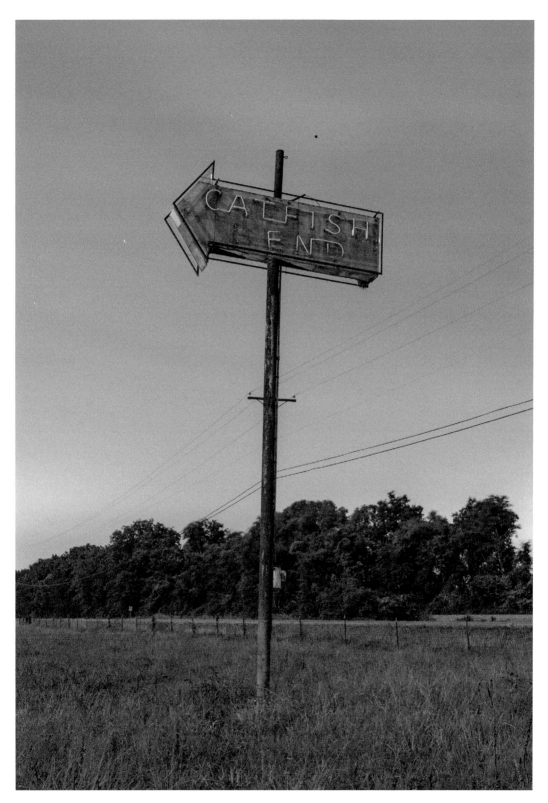

The Catfish Bend restaurant was owned by the Duco family. It opened in 1969 and closed around 2000.

8

A LITTLE LAGNIAPPE

Lagniappe (/ˌlanˈyap/) is a uniquely Louisiana word used to describe something given as a bonus or gift—similar to a baker's dozen, it is "a little something extra." This last set of photos is my gift to you: a set of unique places that I stumbled across that were particularly interesting to me. They include the remains of a fort built to defend Louisiana from the British after the War of 1812, a random collection of store buildings, a crumbling movie set, a bus-turned-advertising sign, Louis Prima's tomb with a trumpet-playing angel, and more. I hope you enjoy them as much as I do.

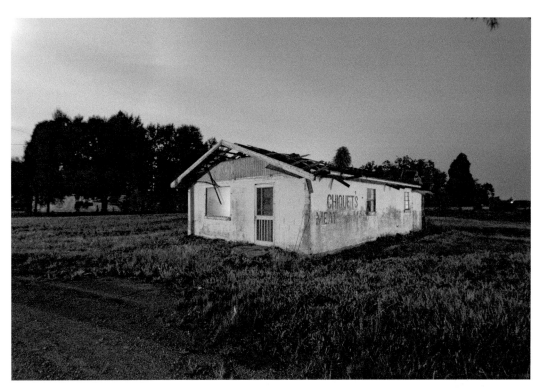

Chiquet's Meat Market was located along the River Road.

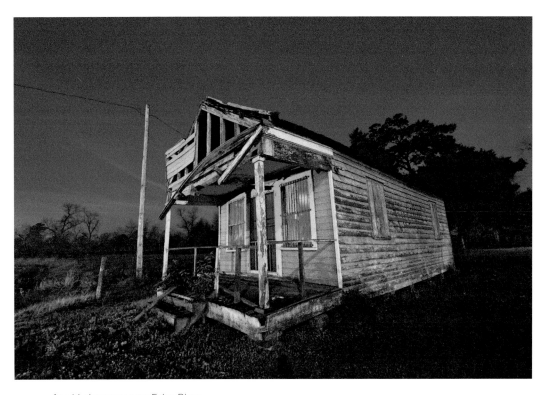

An old pharmacy near False River.

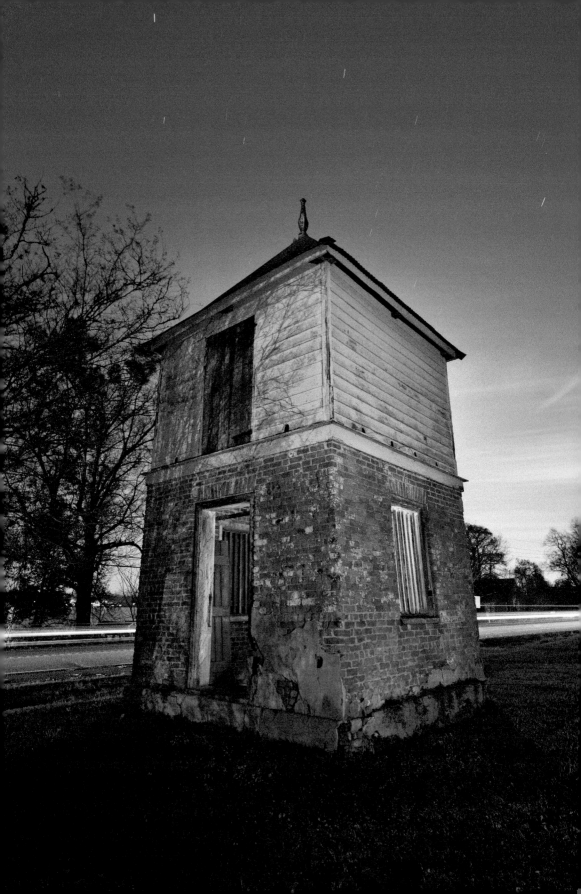

◄ The only remaining pigeonnier at Riverlake Plantation. Pigeonniers (structures used by wealthy French citizens for housing pigeons) are noteworthy, rare features of plantation homes.

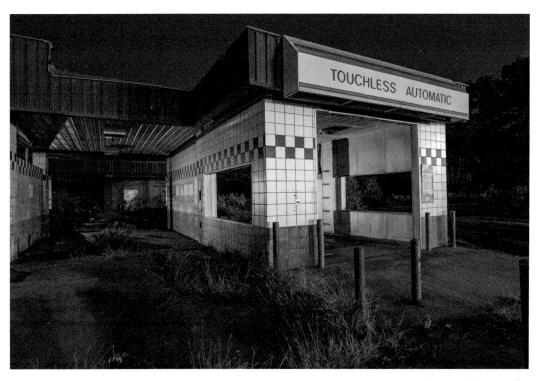

A former car wash.

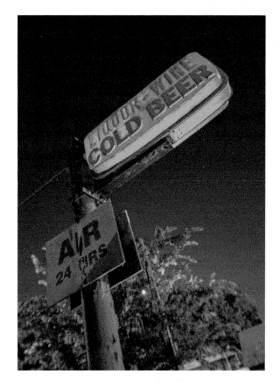

1960s-era grocery store sign in Baton Rouge.

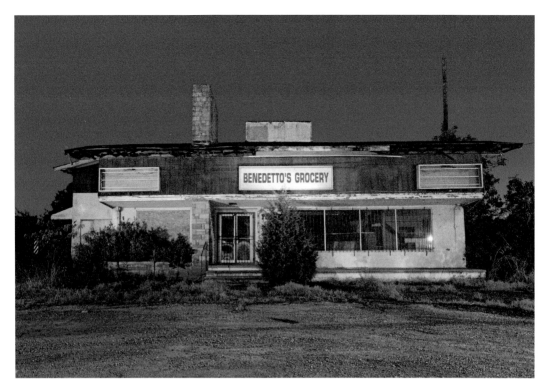

Small, defunct, local grocery store formerly located in West Baton Rouge Parish.

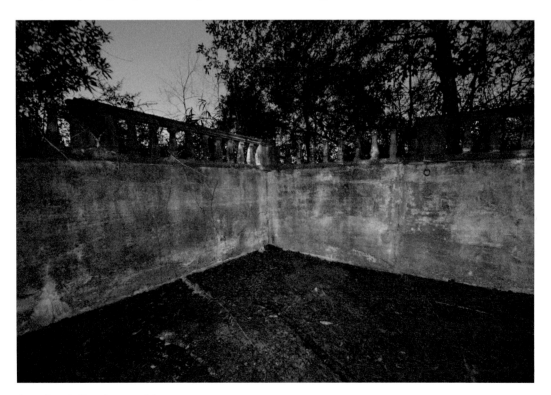

A small pool with unknown origins.

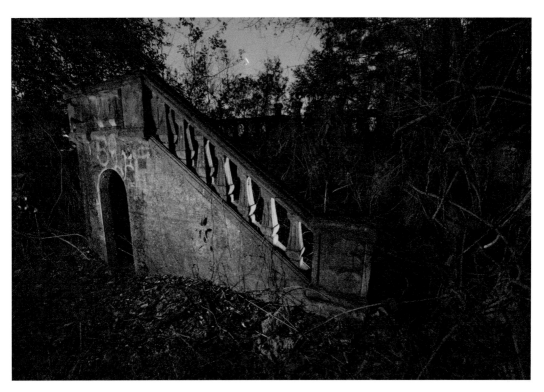

Stairway leading up to a pool that is now being overtaken by nature.

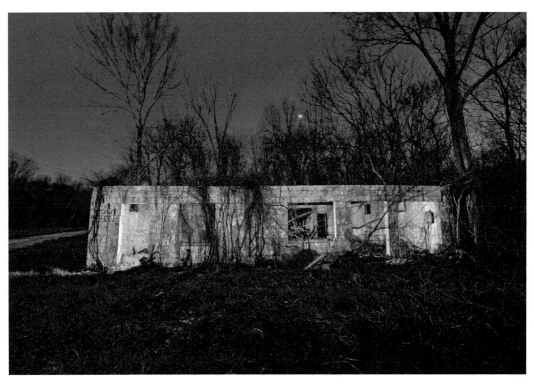

Last remaining bar along a stretch of highway west of Baton Rouge that used to have numerous bars.

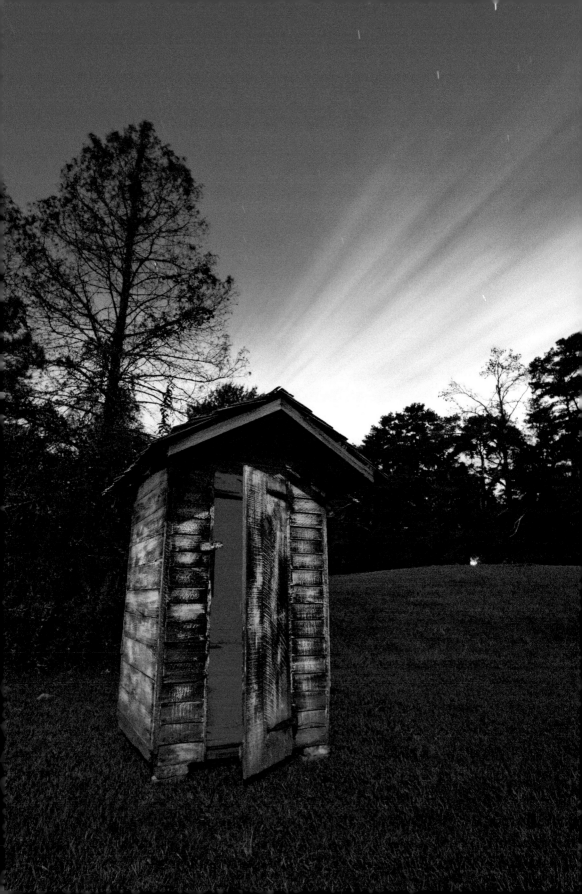

◀ Single-seat outhouse from an old farm.

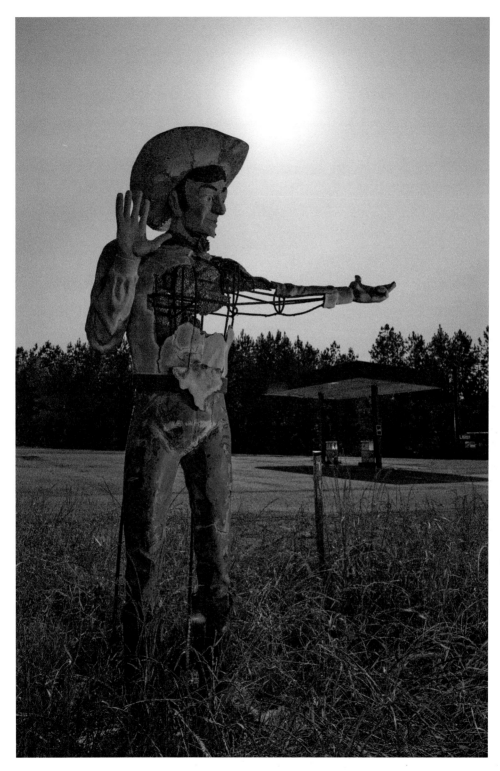

A very tall plaster cowboy that served as an advertisement for a nearby gas station.

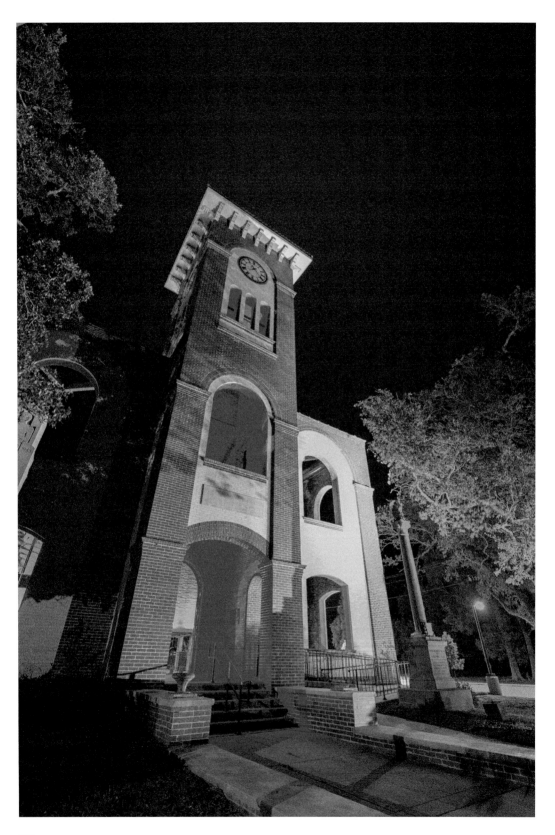

◀ Entryway to the old Plaquemines Parish Courthouse, originally built in 1890. In 2002, it was destroyed by a fire set by arsonists trying to destroy evidence in a case.

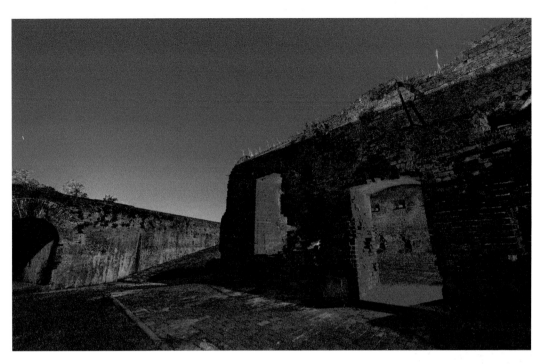

The Citadel at Fort Pike: Fort Pike was built in 1818 to defend New Orleans against a possible British invasion after the War of 1812 and the Battle of New Orleans in 1815. Fort Pike ceased operations in 1890.

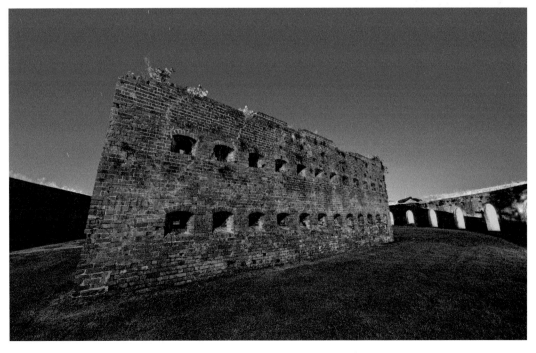

The gun ports for defending Fort Pike.

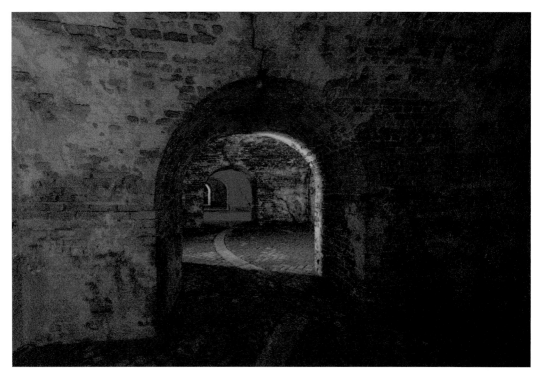

View of the casemates inside the garrison at Fort Pike.

The Streets of Sodom: Ruins of the set for the movie *Year One*.

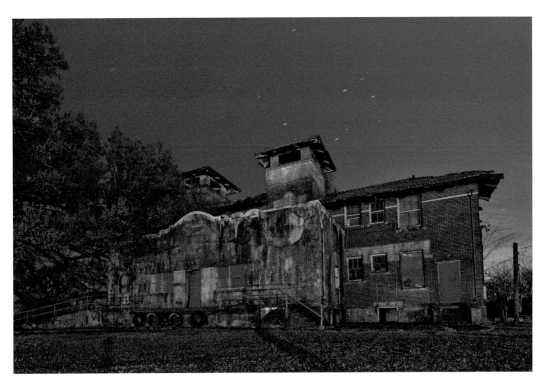

This facility was built in 1908 to house criminally insane women. Inmates lived dormitory-style on two floors of the facility and the basement had offices and a kitchen.

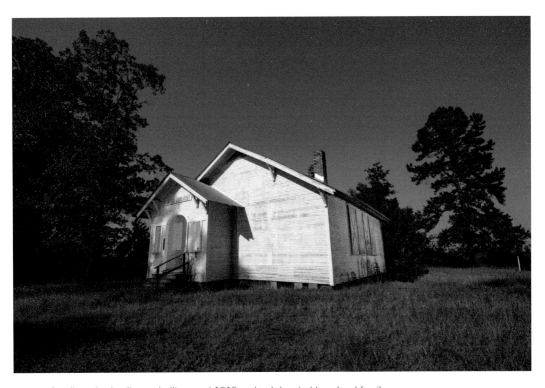

Small rural schoolhouse built around 1915 on land donated by a local family.

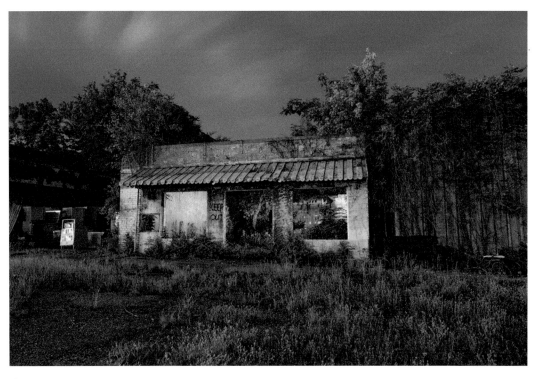

Shell of a former business building whose former line of business has been lost to the ages.

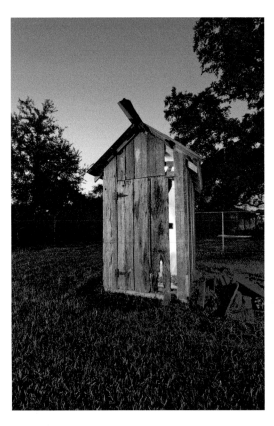

An old outhouse on the former Kleinpeter Plantation in what is now The Settlement at Willow Grove in Baton Rouge.

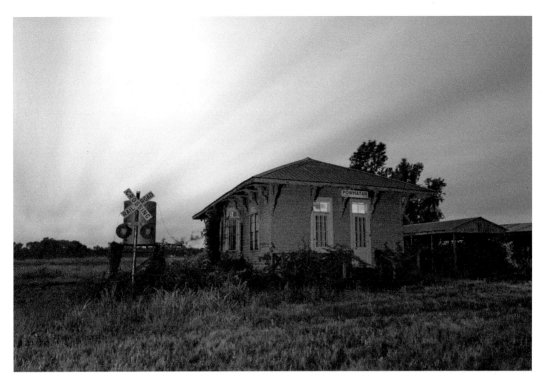

This Texas & Pacific railroad depot in Irene was established in 1902.

Grist mill of unknown age sitting on what was the
Burden family property in Baton Rouge.

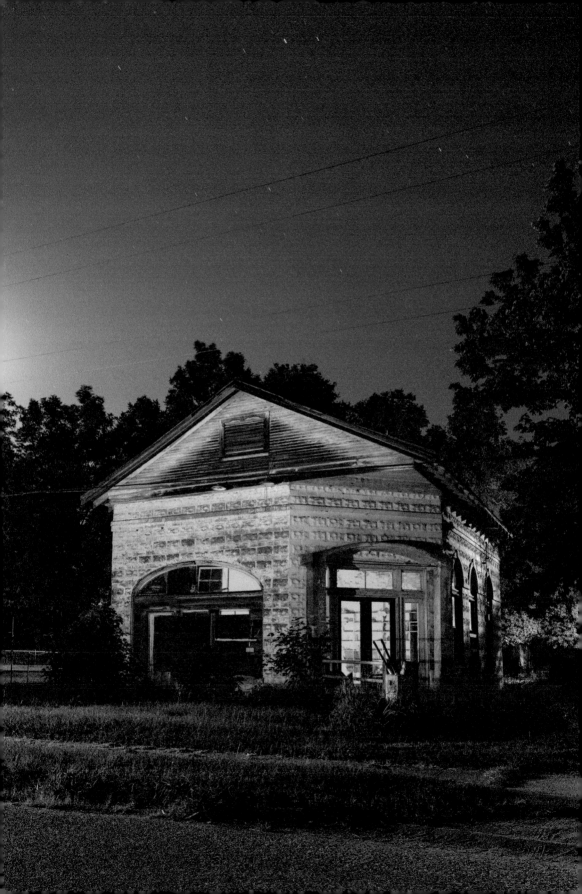

◄ Former bank building established in 1819; this building later housed a bar named Poor Boys.

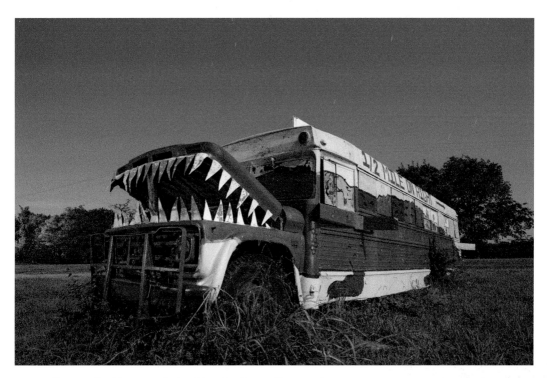

Former school bus-turned-advertising-sign for an alligator park.

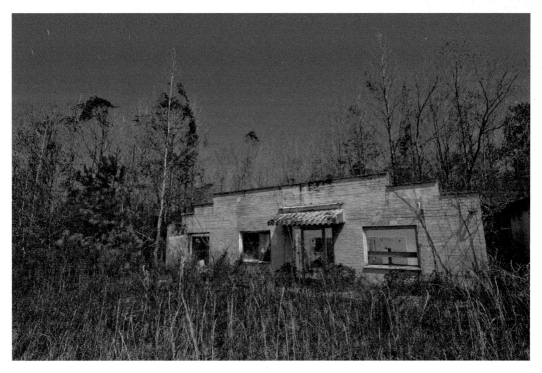

Remains of a former auto parts store along a little used state highway.

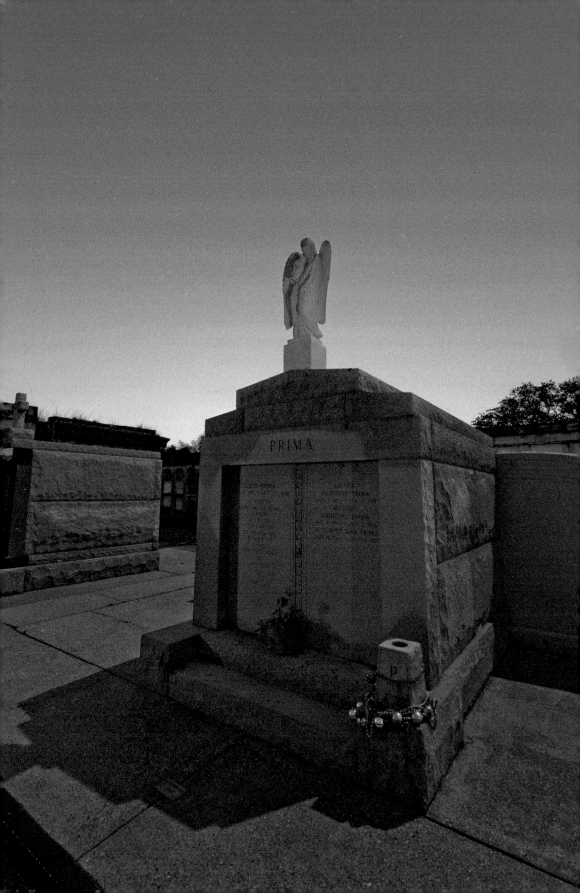

◄ Louis Prima was an extremely successful jazz musician whose career spanned much of the twentieth century. In addition to his coast-to-coast performances, he starred as King Louie in Walt Disney's *The Jungle Book* and recorded the hit *I Wanna be Like You* on the soundtrack. He was born and died in New Orleans, and a tomb topped by the angel Gabriel seems like a very New Orleans-like tribute.

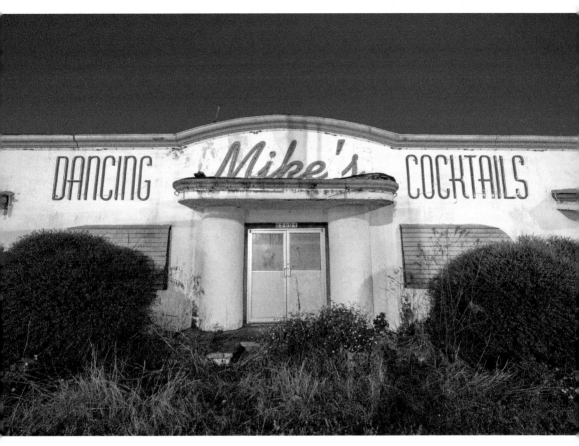

Dancing-Mike's-Cocktails: Bar/nightclub that frequently hosted local bands. The inside resembled a place right out of the 50s with a wooden-floor stage.

ABOUT THE AUTHOR

MIKE COOPER bought a DSLR camera in the late 1990s and started taking vacation photos. After seeing long-exposure night photos of abandoned sites along old Route 66, he started doing research and his first official night photography session occurred on a family vacation on New Year's Eve, 2009. In the years since then, he has traversed the country searching for abandoned locations and photographing those same locations in the dark. His pictures have been included in juried expositions in Tennessee, Texas, and Louisiana, and his extensive portfolio can be seen on Flickr and Instagram under his "Nocturnal Kansas" handle.